MAKING A CHAPUTS

Also by Alan Hoover

Northwest Coast Canoes of Indigenous North America
A Historical View of Styles and Development
Alan Hoover and Eugene Arima, 2021
with contributions from Leslie Lincoln, Joe Martin and J.D. Simpson

Southern Northwest Coast Indigenous Canoe Racing
A Brief History
Alan Hoover, 2018

The Whaling People
of the West Coast of Vancouver Island and Cape Flattery
Eugene Arima and Alan Hoover, 2011

The Magic Leaves
A History of Haida Argillite Carving
Peter Macnair and Alan Hoover, 2003

Nuu-chah-nulth Voices, Histories, Objects and Journeys
Alan Hoover (editor), 2000

MAKING A
CHAPUTS

The Teachings and Responsibilities of a Canoe Maker

JOE MARTIN and **ALAN HOOVER**

ROYAL **BC** MUSEUM
VICTORIA, CANADA

Making a Chaputs
The Teachings and Responsibilities of a Canoe Maker

Published by the Royal BC Museum, 675 Belleville Street,
Victoria, British Columbia, v8w 9w2, Canada.

The Royal BC Museum is located on the traditional territories
of the Lekwungen (Songhees and Xwsepsum Nations). We extend
our appreciation for the opportunity to live and learn on this territory.

Cover, interior design and typesetting by Lara Minja, Lime Design

Front cover photo © Leigh Hilbert, 1984. Caption on page 21.
Joe Martin author photo (back flap) © Melissa Renwick 2021.

Library and Archives Canada Cataloguing in Publication

Title: Making a chaputs : the teachings and responsibilities of a canoe
 maker / Joe Martin and Alan Hoover.
Names: Martin, Joe (Canoe maker), author. | Hoover, Alan L., author.
 Royal British Columbia Museum, issuing body.
Description: Includes bibliographical references.
Identifiers: Canadiana (print) 20210366524 | Canadiana (ebook)
 20210366737 | ISBN 9780772680273 (softcover) |
 ISBN 9780772680297 (EPUB)
Subjects: LCSH: Dugout canoes—Northwest Coast of North America.
 LCSH: Canoes and canoeing—Northwest Coast of North America.
 LCSH: Boatbuilding—Northwest Coast of North America. | LCSH:
 Boatbuilders—Northwest Coast of North America. | LCSH: Carving
 (Decorative arts)—Northwest Coast of North America. | LCSH:
 Indigenous art—Northwest Coast of North America.
Classification: LCC E98.B6 M37 2022 | DDC 623.8/129—dc23

10 9 8 7 6 5 4 3 2 1

Printed in Canada by Friesens.

I DEDICATE THIS BOOK to my late brother Bill Martin; my late father, Robert Martin Sr., who was my main teacher; my grandfather Nuukmiis (George Martin); my grandfather from my mother, Placide Lucas; and finally, the late Chief Ben Andrews of the Hesquiaht First Nation.

My brother Bill worked with me on several canoes, many of which we did together in the forest around Kennedy Lake. Bill suffered from abuses that he endured while attending the Alberni and the Christi Indian residential schools. Christi was located where the Best Western Tin Wis is now situated. Many Nuu-chah-nulth children were forced to attend these and other residential schools, where they were punished if they spoke their own language and were subjected to physical and sexual abuse.

I witnessed my late brother Bill as happiest while we were carving canoes in the forest at home in Tla-o-qui-aht Tribal Parks. He was talented and ambidextrous, and he worked very hard.

—JOE MARTIN

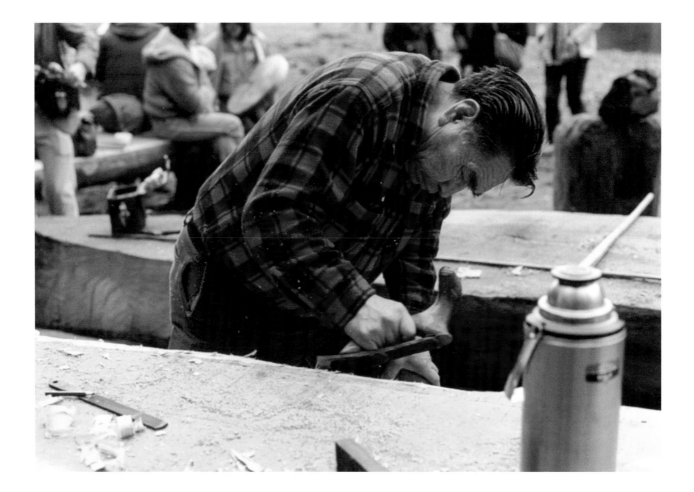

Chief Robert Martin Sr. adzing. Wanačis ḥiɫhuuʔis (Meares Island), 1984. LEIGH HILBERT PHOTOGRAPH.

Contents

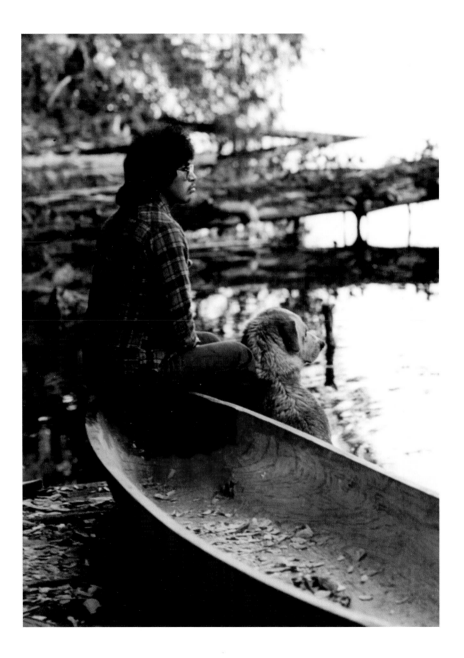

Bill Martin and his dog Slash, Wanačis ḥiłhuuʔis (Meares Island), 1984.
LEE HILBERT PHOTOGRAPH.

About This Book

This publication is a collaboration between Tla-o-qui-aht canoe-maker Joe Martin and former museum curator Alan Hoover. The majority of the text, including the description of the actual making of a dugout canoe, is in Joe's own words. Alan provided additional information and photographic labels. In the main text, Joe's words are in a serif font in black, Alan's in a sans serif font in blue. A short glossary following the main text explains a few canoe-making terms.

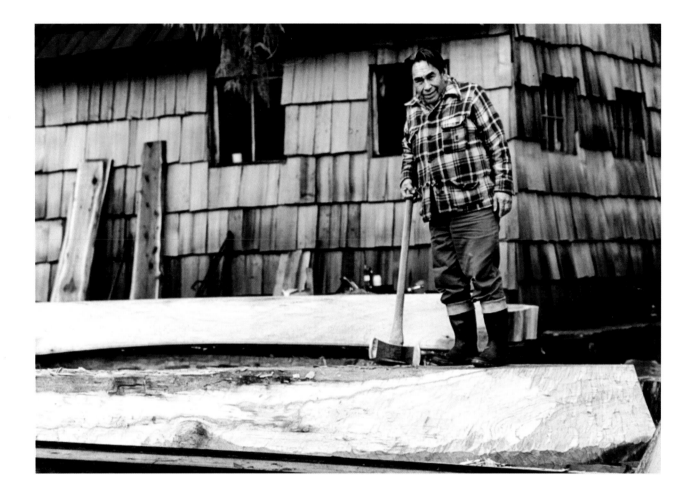

My father, Chief Robert Martin Sr., continued to live in this cabin after the blockade. It was here that he received the court ruling which included the injunction that stopped logging on Meares Island. LEIGH HILBERT PHOTOGRAPH.

Introduction

MY NAME IS JOE MARTIN. My traditional name is Tuu-tah-qwees nup-she-tl (Tutakwisnapšiλ), a traditional name from our house. After I was born in Tofino General Hospital was when I had my first canoe ride. My father picked up my mother and me in a canoe and brought us from Tofino to our home at Opitsaht village.

Being out on the ocean a lot, my father often spoke about the mountains, where the songs and dances of the Tla-o-qui-aht were conceived. Every mountain was known by its Tla-o-qui-aht or Nuu-chah-nulth name. Other names referred to fishing grounds in Tla-o-qui-aht Haa-huu-thli (territory) or where the ha-wiih (hereditary chiefs) and whalers went to pray before the beginning of the whale hunting season.

Canoes were treated with much care, as they were an essential part of Nuu-chah-nulth culture as the main means of transportation. Therefore it was very important for the males of the tribes to know how to make a canoe. This teaching began at a very young age and continued throughout life as one learned about the Laws regarding the use of any resource needed by the people. This is what I would like to share with you in this book about the art of canoe making.

In 1981 we paddled from Tofino up to Nootka Sound, around Nootka Island, and back. Eleven people departed, but only five or six returned—people bailed out along the way. We shot a seal and ate it, also a deer. We also caught salmon, barnacles and mussels, and an octopus. We had to launch through huge surf one day. The 27-foot canoe nearly got airborne while punching out!*

* "Tofino Canoe Carver Joe Martin," *Tofino Time*, March 2016, https://www.tofinotime.com/artists/R-JMfrm.htm.

I became a canoe carver. I started carving canoes many years ago when I was very, very young. My father, Robert Martin Sr., didn't leave me a choice or not to go: "Get ready, we're going." Anyhow I had no choice to go. So I finally started going with him. It didn't really dawn on me until many years later that this is something that I really love to do. I actually started seriously doing this at the Meares Island Blockade in 1984. Since then I have carved, oh gosh, I don't know, more than 60 canoes.

The 1984 Blockade of industrial logging by the MacMillan Bloedel company on Meares Island in Clayoquot Sound led to the Tla-o-qui-aht declaring Wanačis ḥiłhuuʔis (Meares Island) a tribal park and winning a court injunction against the company and the Province of BC that prevented further logging.

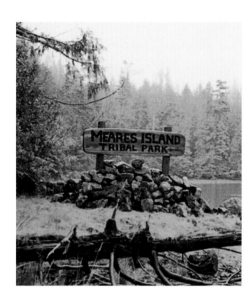

(*above*) Wanačis ḥiłhuuʔis (Meares Island) Tribal Park, 1984. COURTESY OF *HA-SHILTH-SA NEWSPAPER*.

(*facing*) The Haa-huu-thli (traditional territory) of the Tla-o-qui-aht ha-wiih (chiefs) and surrounding Nuu-chah-nulth Nations.

I WOULD LIKE TO now acknowledge all the individuals and NGOs who did come and support this endeavour, which cost Tla-o-qui-aht five million dollars or more. Much was raised by other Nuu-chah-nulth Nations and other tribes across Canada, as well as all the NGOs, who did help very much. For that I am very grateful, as will be the future generations of people who live here.

This was a very special time, as many different people came to support, including the late Ahousaht historian John Jacobson and the late Bernie (Bernard Remy) Smith, who was an artist who did paint the covers for Harlequin novels. While he was at C is-a-qis, he did paint a portrait of my late father, Robert Martin Sr., and a scene from the shore at C'is-a-qis with my brother Carl Martin's dog Slash sitting on the beach as Carl and Bill paddled out in a canoe to pick someone up, a painting of my uncle Moses Martin's and my father's fishing boats *Meridian* and the *MicMac 2* that were anchored there, and a portrait of me carving on a canoe (see page 4). After Bernie Smith passed away a few years ago, he had many paintings which he had stored. His two sons, Brett and Paul Smith, found me through the internet and came to Tofino to meet and bring the paintings which their father had done at that time. My family and I are very grateful to have received these beautiful paintings by the late Bernie Smith.

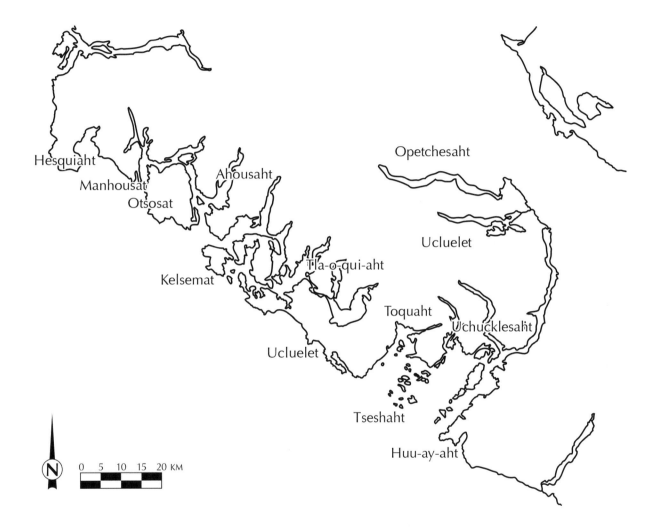

Hesquiaht

Manhousat

Otsosat

Ahousaht

Opetchesaht

Kelsemat

Tla-o-qui-aht

Ucluelet

Ucluelet

Toquaht

Uchucklesaht

Tseshaht

Huu-ay-aht

N

0 5 10 15 20 KM

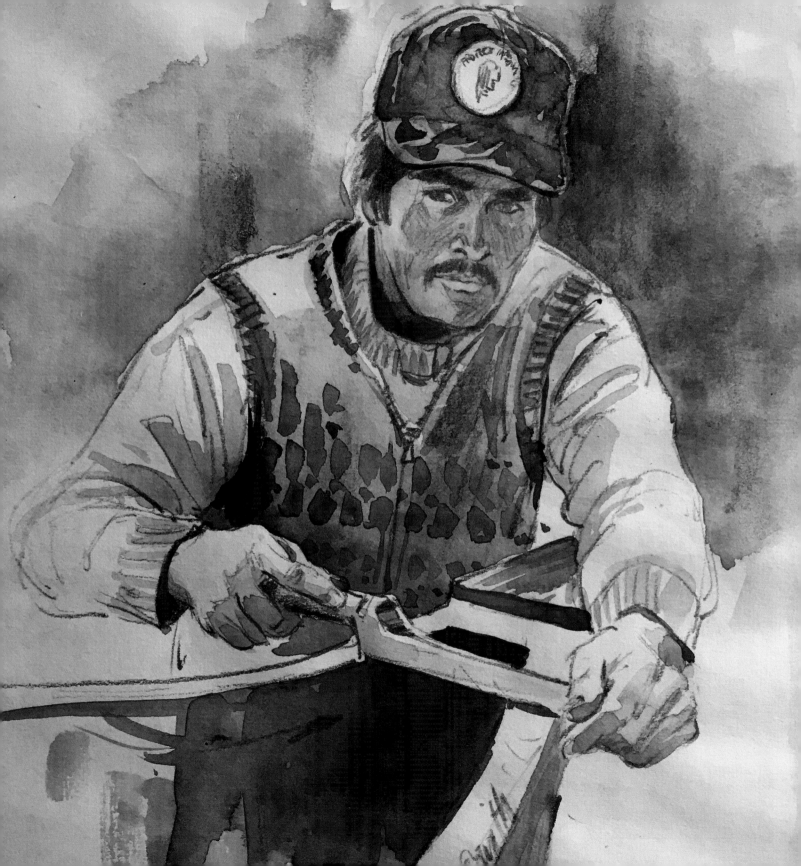

Building Canoes
Meares Island Tribal Park, 1984

WHILE BLOCKADING for three months at C′is-a-qis (Heelboom Bay), my late father, Robert Martin Sr.; my two brothers, Carl and Bill Martin; and I carved three canoes to demonstrate our use of our forest, while helicopters occasionally hovered overhead, taking photographs of many people who were there. We carved them the way the old people did.

> I myself did work in forestry for twelve years before the blockade . . . it was a well-paying job . . . but it was just getting too much for me. When it was raining real hard, I'd see the soil from the clearcuts sliding into Kennedy Lake and the streams. . . . I knew that's where our salmon lived. It was horrible to see. . . . Yes, it really bothered me. I couldn't stand it anymore and quit my job! I then spent several months with my father over here at Cis-a-qis blockade.[*]

—JOE MARTIN

Portrait of Joe Martin by Bernie (Bernard Remy) Smith, 1984. TSIMKA MARTIN PHOTOGRAPH, 2021.

[*] Joe quoted in Gleb Raygorodetsky, *The Archipelago of Hope: Wisdom and Resilience From the Edge of Climate Change* (New York & London: Pegasus Books, 2017), 224.

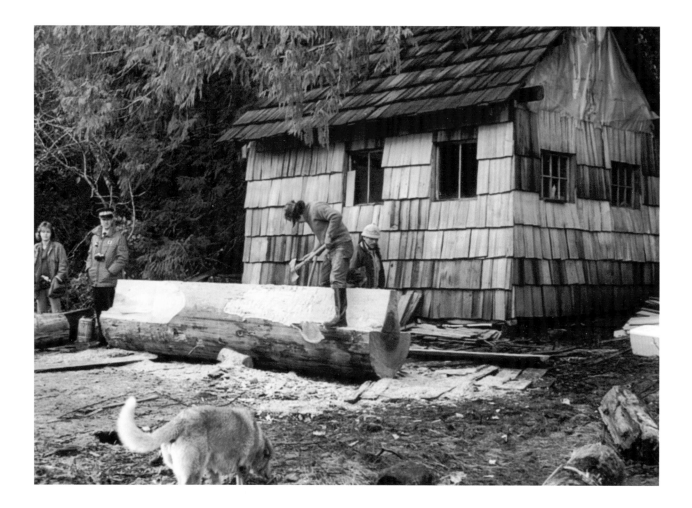

I'm shaping the sides of the canoe log with an axe in front of the cabin we built during the Meares Island blockade of 1984. LEIGH HILBERT PHOTOGRAPH, 1984.

In the former days the ancestors split the log through the core using wooden wedges, carefully driving them in alternately to create the even splitting. When large logs were plentiful, they adzed them down to a flat surface from the outer edge of the log to the centre core, which will then be the bottom of the canoe, resulting in a canoe that will have edge-grain wood throughout most of the hull.

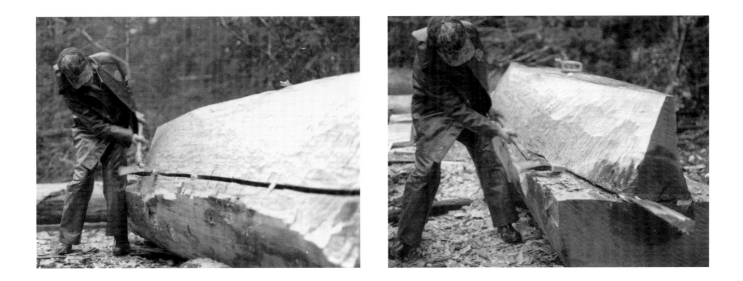

I'm pounding in wedges to split the upper, shaped half of the canoe log from the bottom half. This log did not have enough width to have the bottom of the canoe at the centre or core of the log. LEIGH HILBERT PHOTOGRAPHS, 1984.

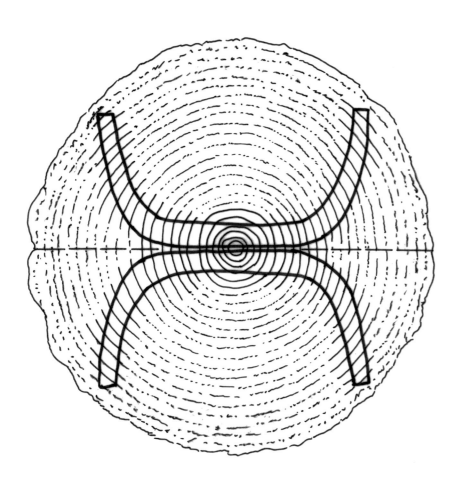

This diagram shows how two edge-grained canoes can be obtained from one log split through the core. The presence of the core provides extra strength. Edge or cross-grain canoes are less likely than flat-grain canoes to split in heavy seas or to "check" (see glossary) when left in the sun without being covered.

LENI HOOVER DIAGRAM BASED ON A SKETCH BY JOE MARTIN.

I have used this technique for some time. My dad and grandfather made canoes this way. But it is harder to find big logs and make the larger canoes that customers want. By carving the canoe so the bottom is at the outside of the log, I can make larger-sized canoes from the smaller logs that are now available.

Diagram showing the greater width obtained from a canoe log when carving a flat-grain hull (bottom) compared with an edge-grain hull (top).

LENI HOOVER DIAGRAM.

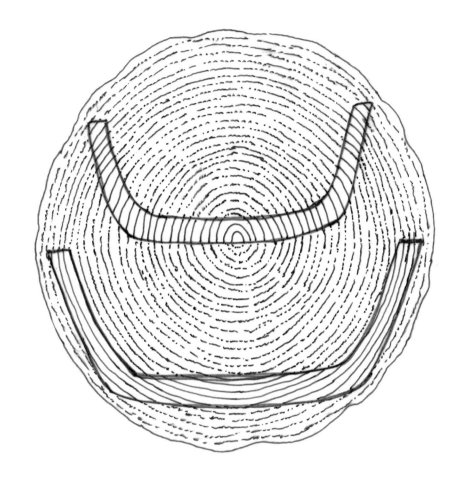

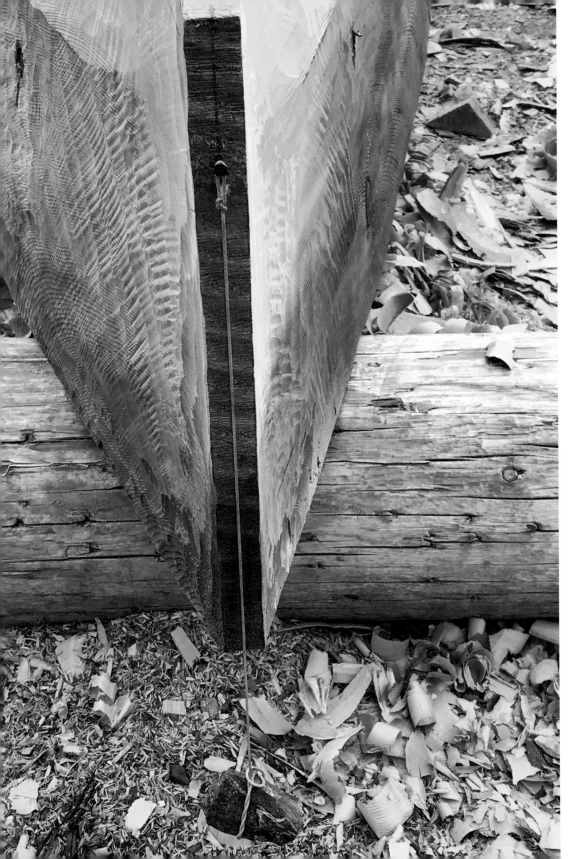

Levelling the canoe before finishing the outside of the hull. A rock and string are used to create a plumb line.

JOE MARTIN PHOTOGRAPH.

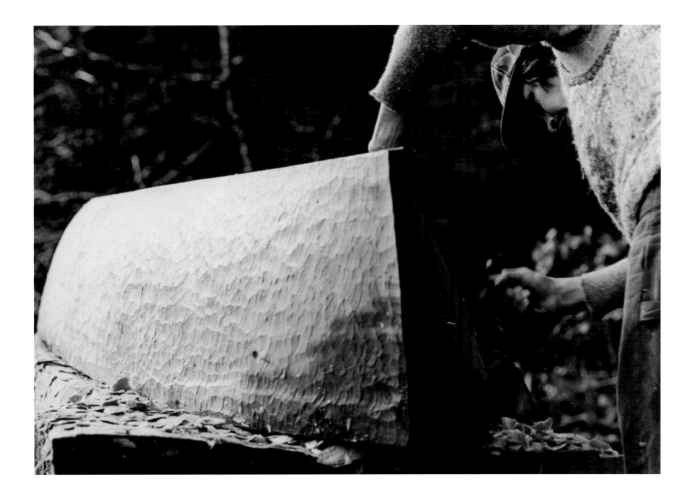

I'm shaping the upper half of the log with a D-adze. LEIGH HILBERT PHOTOGRAPH, 1984.

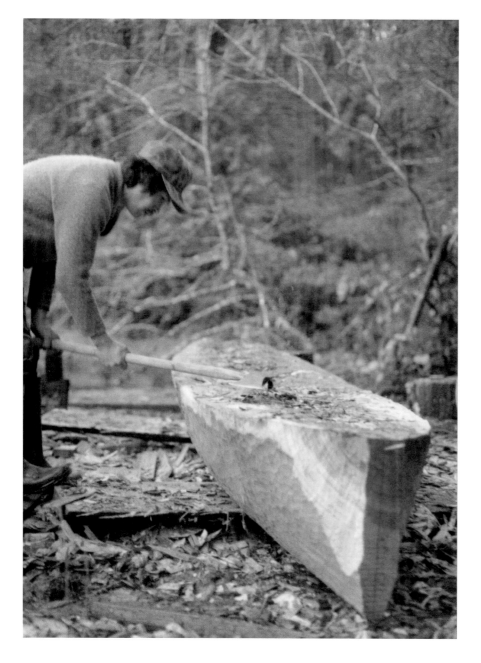

I'm cutting in the sheer line, the top edge of the canoe hull, with a double-bladed axe.

LEIGH HILBERT PHOTOGRAPH, 1984.

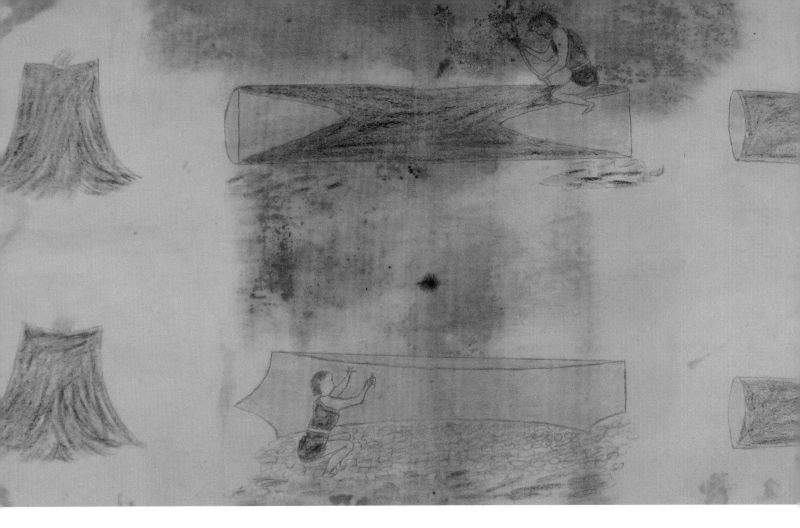

Nuu-chah-nulth narrative colour drawing of canoe making. The canoe maker is using a single-bladed axe in the upper panel and a D-adze in the lower panel. Created at Port Alberni in 1908 by an artist who was a tuberculosis patient at the Alberni Boarding School. ROYAL BC MUSEUM 2013.1.1.

THIS PAGE AND THE NEXT illustrate the making of a canoe in two sequential panels. The artist has illustrated straight cuts, showing that the tree was cut down using a saw. In 1908, this would have been a large two-man cross-cut saw, not a power saw. In the upper panel of the drawing, the canoe maker is using a single-bladed axe, preparing the log by removing bark and beginning the shaping of each end. In the lower panel the work has progressed to the point where the two ends are now differentiated. The bow is at the viewer's left, and the vertical profile of the stern is at the viewer's right.

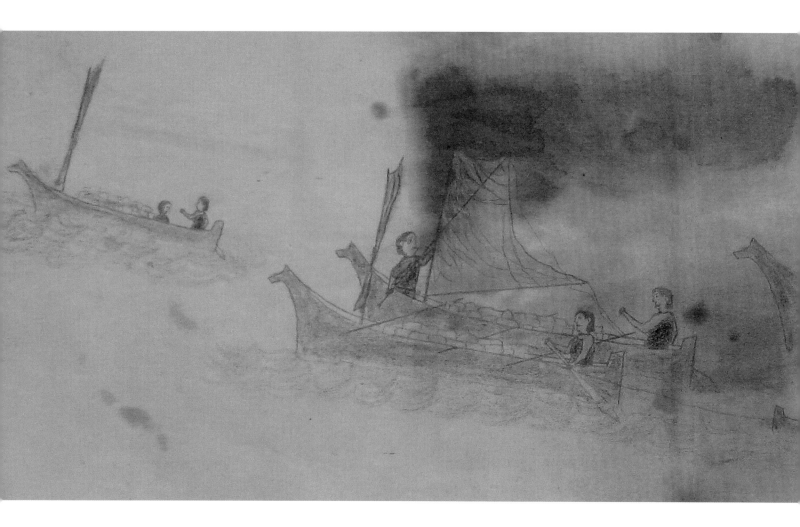

Moving house boards and possessions. Five of the canoes are rigged with spritsails. The four larger canoes are rafted together in pairs. In the middle of the drawing, a crew member can be seen rigging the sail by placing the diagonal spar or "sprit" in place. Created at Port Alberni in 1908 by the same artist who created the narrative drawing on the previous page. Unfortunately, the artist's name was not recorded. ROYAL BC MUSEUM 2013.1.1.

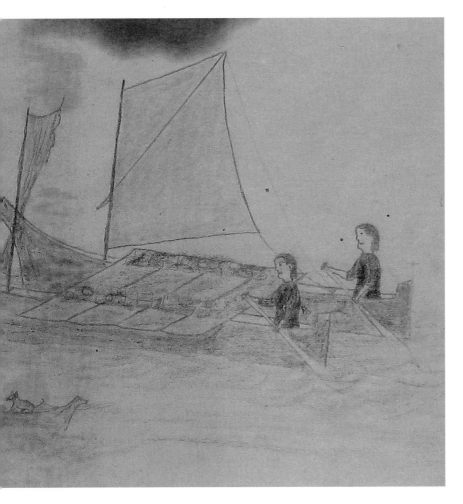

The importance of canoes and canoe making to the Nuu-chah-nulth is reflected in an 1891 census of Indigenous men on Vancouver Island. Out of 81 identified canoe makers, 71—an astounding 87 per cent—were Nuu-chah-nulth.

When Federal Indian Reserve Commissioner Peter O'Reilly visited Barkley Sound in October 1882, he wrote that red cedar of "large size is abundant and is especially valued by the Indians for making canoes, an industry successfully carried out by them."*

These two illustrations are two of 20 pencil and coloured-pencil drawings in a sketchbook held at the Royal BC Museum. According to a difficult-to-read inscription on the back of the sketchbook, the drawings were made "By an old Indian age 85 for J.R. Motion in who's [sic] care he became while dying of T.B. (Mission School)." J. R. (James Russell) Motion (1869–1936) was the principal of the Presbyterian-run Alberni Boarding School, known as the Alberni Residential School, in 1900, and left the institution in September 1909. The Department of Indian Affairs annual report for 1902 notes that Motion and the school staff visited and cared for the sick. It is unclear where the artist was located when he produced the drawings, but the inclusion of the phrase "Mission

* Peter O'Reilly, letter to the Superintendent General of Indian Affairs, October 9, 1882, in *Annual Report of the Department of Indian Affairs for the Year Ended 31st December 1882* (Ottawa: Government of Canada, 1883). https://central. bac-lac.gc.ca/.item/?id=1882-IAAR-RAAI&op=pdf&app=indianaffairs

School" suggests that he was at the Alberni Residential School. There were no dedicated medical facilities open to First Nations people for treatment until the 1940s, so an Elder's presence at the residential school is not unexpected.

As early as 1905, it was recognized by the Chief Medical Officer of the Department of Indian Affairs that tuberculosis (TB) was a major cause of high rates of illness and death among First Nations adults and children. Tragically, the children were often infected at overcrowded and understaffed so-called schools where they suffered malnutrition, overwork and abuse.* The drawings were donated to the museum by a descendant of James Russell Motion.

I CARVED THREE CANOES for the Meares Island Protest as a demonstration of our peoples' connection to the forest. The canoes represent to me all those resources that we as native people have a cultural right to. The canoe represents the Nuu-chah-nulth.

* See Mary-Ellen Kelm, *Colonizing Bodies: Aboriginal Health and Healing in British Columbia, 1900–1950* (Vancouver: UBC Press, 1998); Nuu-chah-nulth Tribal Council 1996.

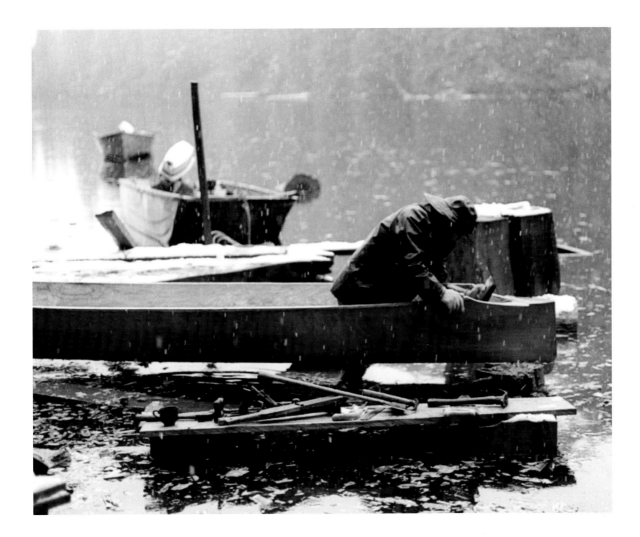

Dad working in the snow. The tide came in and almost floated him—he kept working.

LEIGH HILBERT PHOTOGRAPH, 1984.

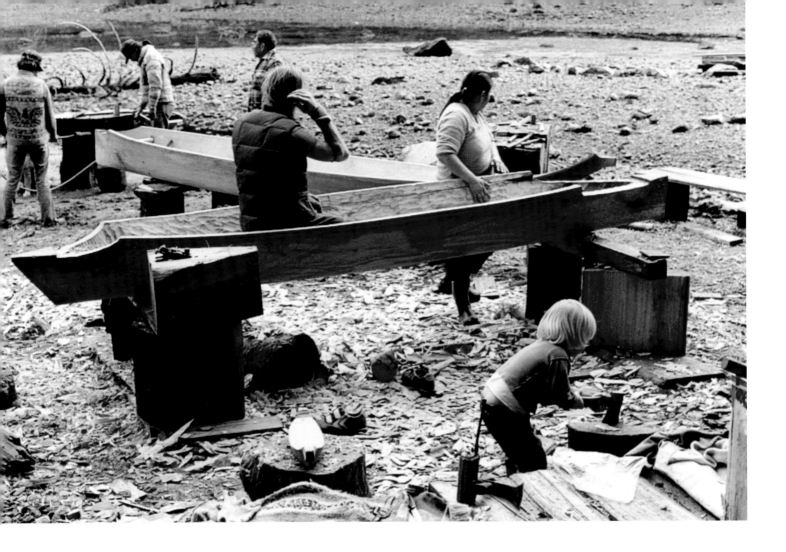

Two of the three canoes made by myself, my brothers Carl and Bill, and our father Robert Martin Sr. during the Meares Island blockade in 1984. The little boy is the photographer's son Jesse. LEIGH HILBERT PHOTOGRAPH, 1984.

One of these canoes was given to the late Chief Alec Frank's family for the songs they sang at a number of our family potlatches. A second canoe is on exhibit in the Aerie Eagle Gallery in Tofino, owned by the Tsimshian artist Roy Henry Vickers.

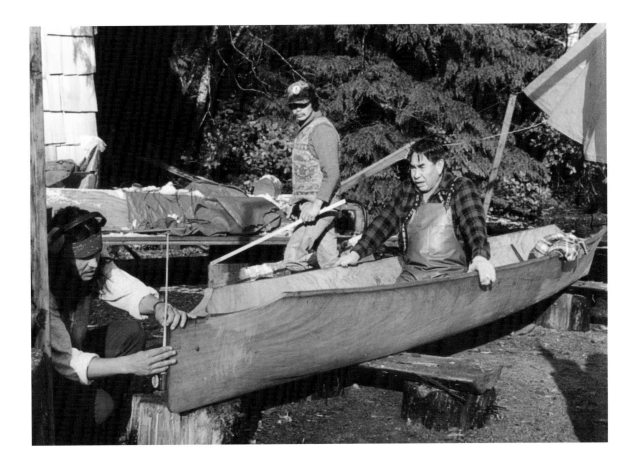

Robert Martin Sr. (in canoe), Joe Martin (background) and Carl Martin. C`is-a-qis (Heelboom Bay), Wanačis ḥiłhuuʔis (Meares Island), 1984. LEIGH HILBERT PHOTOGRAPH.

On these two pages, the canoe hulls have been shaped, turned over and hollowed, and the bow and stern have been prepared before fitting in the stern and bow heads. On this page, my brother Carl Martin is measuring the height of the stern to figure out how high the stern piece add-on should be. Pages 20 and 21 show how the separate stern and bow heads were attached to the canoe hull.

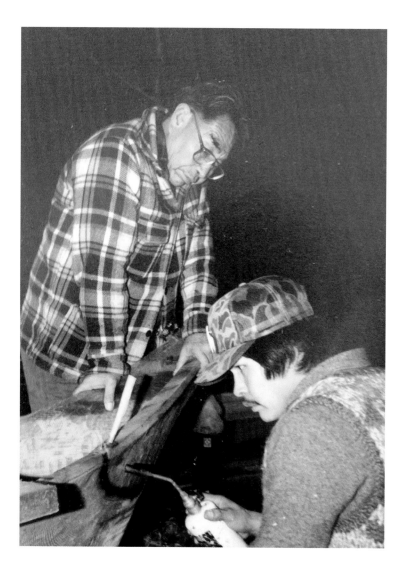

Chief Robert Martin Sr. watching his son Joe pegging
and gluing the bow piece on a chaputs hull. The bow piece
was attached using three pegs and then tied with spruce root. Spruce
gum was used to seal the joint between the hull and bow piece.

LEIGH HILBERT PHOTOGRAPH, 1984.

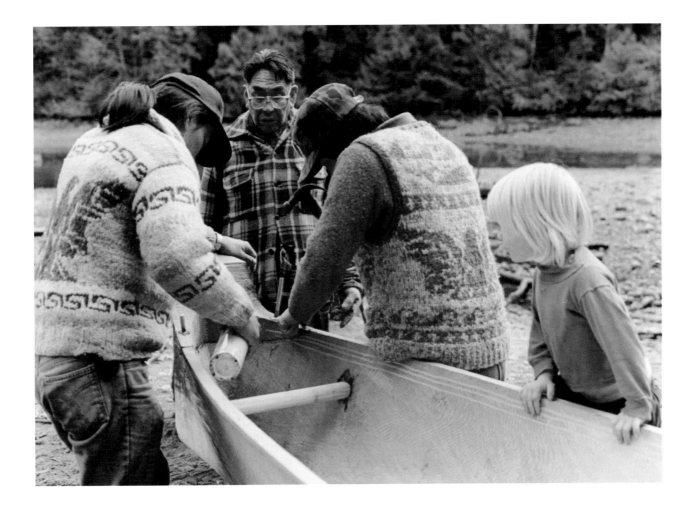

Fitting the stern piece. Chief Robert Martin Sr. (centre), Carl Martin (left), Joe Martin (right) and young Jesse Hilbert. The stern piece was pegged and the joint sealed with spruce gum and tied with spruce root. C´is-a-qis (Heelboom Bay), Meares Island, 1984. LEIGH HILBERT PHOTOGRAPH.

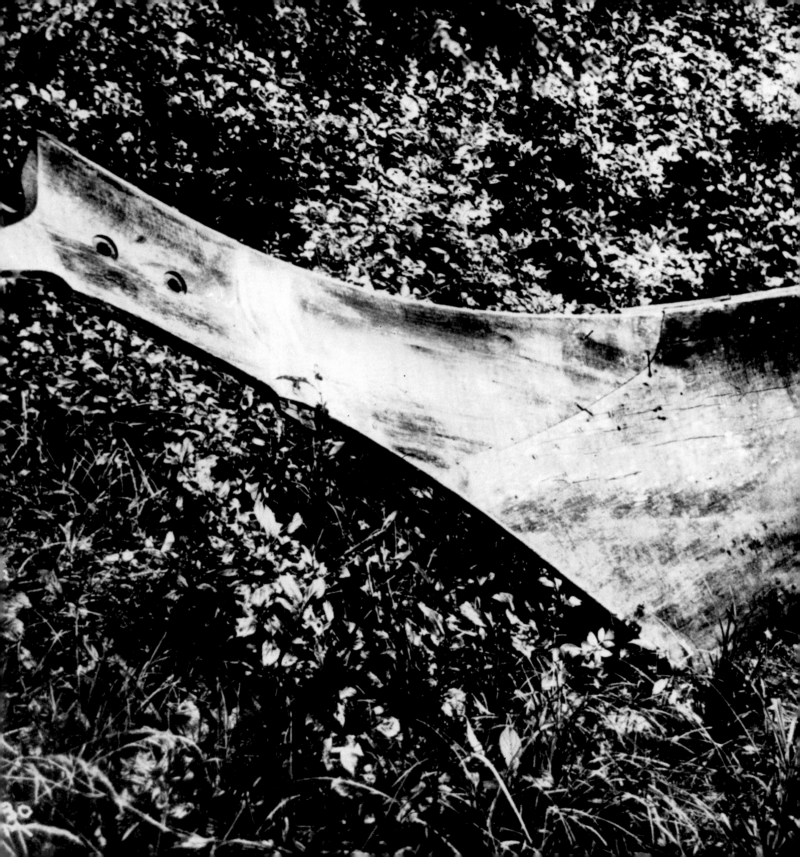

Canoe Sizes

THERE WERE SEVERAL different sizes of canoes which were made, from very small ones to the largest about 60 feet or more. The most common ones were about 24 feet and 32 to 36 feet in length.

Nuu-chah-nulth giant canoe, approximately 55 feet long with a beam of 6 feet. The canoe was made by ʔôdayo. According to one source, its size made it unmanageable in the winds and tides of the Strait of Juan de Fuca.* Photograph taken in 1912 near the mouth of Nitinat Lake. I do not believe that this canoe was "unmanageable." Nuu-chah-nulth ancestors had the knowledge and ability to move it from where it grew as a monumental western red cedar to the water to float it. Looking at other canoe cultures, the Māori of New Zealand still use canoes up to 100 feet long. I have heard of shaped canoes of that size pulled out of the ancestral forests along the Kennedy Flats [western end of Kennedy Lake] along what is called West Main logging road, inside of Tla-o-qui-aht Tribal Parks. ROYAL BC MUSEUM PN 704.

* Eugene Y. Arima, *The West Coast (Nootka) People*, Special Publication No. 6 (Victoria: British Columbia Provincial Museum, 1983), 37.

THE USE OF NUU-CHAH-NULTH CANOES for recreation has a long history. In a 1905 photograph (pages 26–27) guests celebrate the marriage of Sarah, the daughter of Ucluelet resident Dr. Charles MacLean, and William Lowell Thompson, the grandfather of D'Arcy Thompson of Ucluelet. Dr. MacLean provided medical care to the Indigenous people of Hitacu (Ittatsoo) village and to settlers in Ucluelet and the area. We do not know the identity of the canoe owner, but it was probably one of Indigenous men in the canoe. Among them are Solomon Peter, Barney (brother of Chief Johnny), Quiet Tom, Francis Williams, Tutube, Chief Johnny, Kvarno, and Robert Williams.[*]

[*] Thanks to D'Arcy, Carol and Margaret Thompson, Jenny Geddes, Barb Gudbranson, and Shirley Martin for two lists of the canoe occupants.

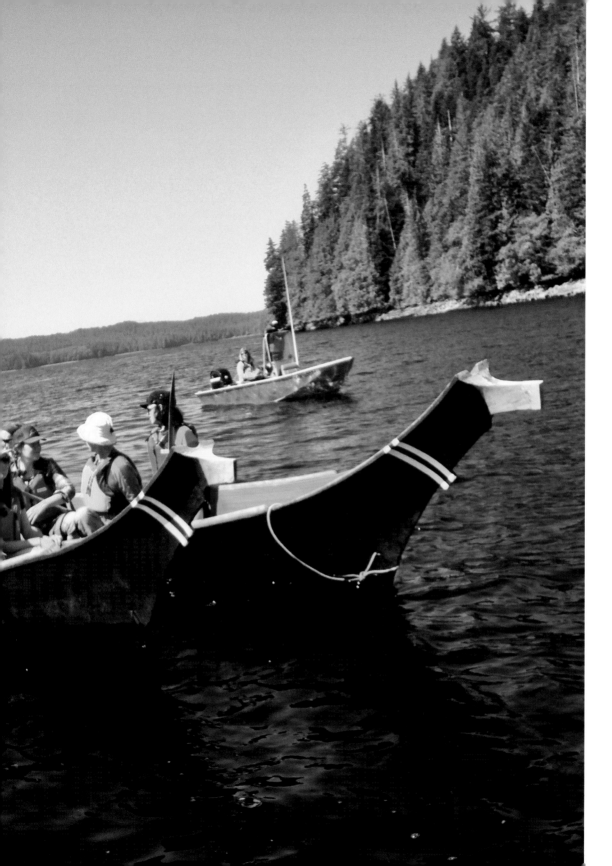

Two of my canoes. The larger canoe is 34 feet long, the smaller canoe 22 feet long. Both canoes were made from the same tree. They are being used to conduct eco-cultural tours of the traditional territory of the Tla-o-qui-aht Nation, led by my daughters Gisele and Tsimka Martin.

JOE MARTIN PHOTOGRAPH.

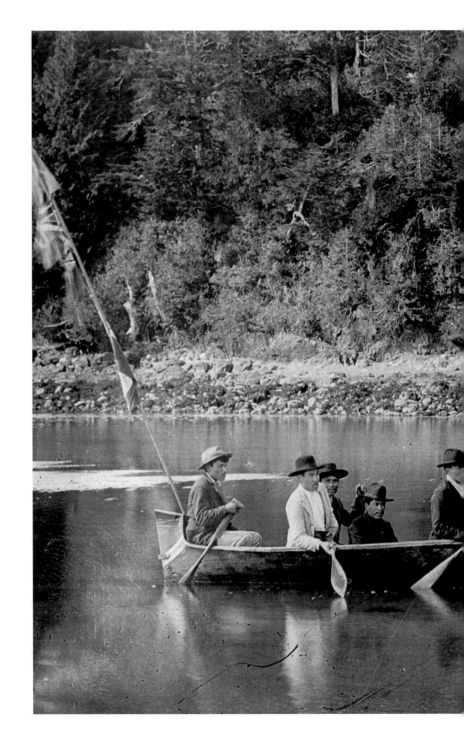

A large party of wedding guests, including Indigenous people and settlers, enjoying a canoe ride and picnic. Ucluelet, 1903 or 1905.

ROYAL BC MUSEUM PN 1137.

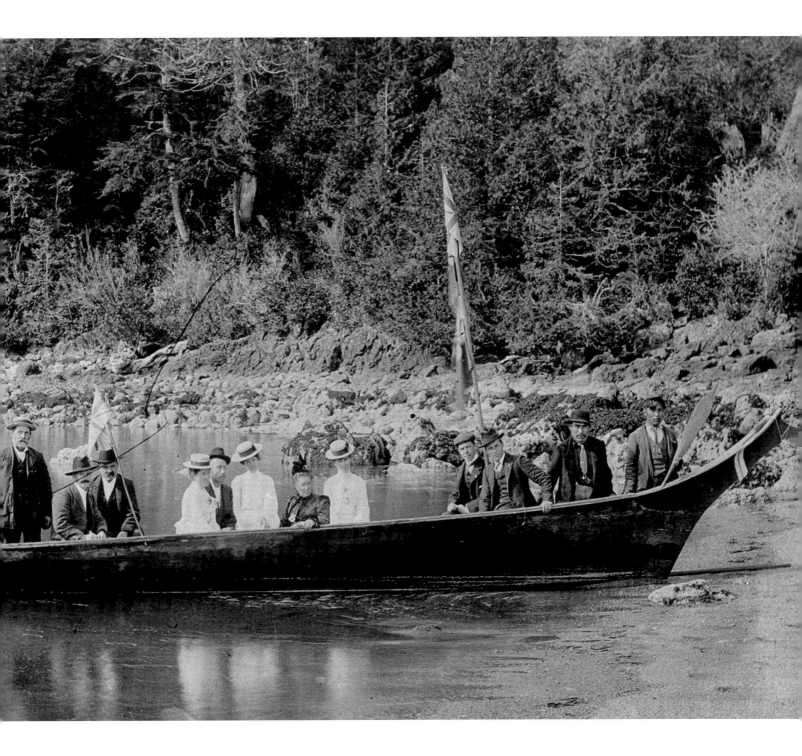

Hummingbird: A Canoe Carved for the Makah Nation

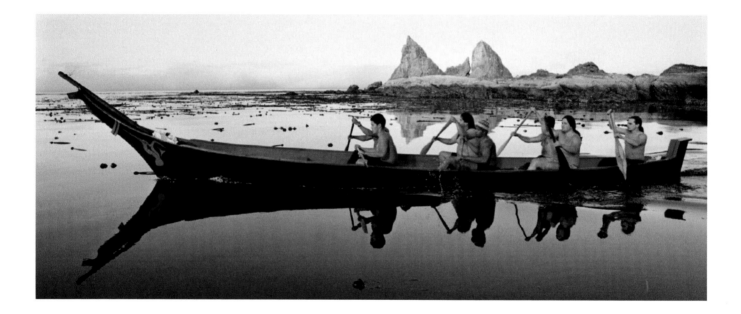

Hummingbird, 32-foot whaling canoe. Near
Neah Bay, Washington State, August 20,
1998. PHOTOGRAPH BY ELAINE THOMPSON – AP/
THE CANADIAN PRESS.

I NEVER DREAMED when I was carving this canoe that it would harpoon a whale. The name of that canoe is the *Hummingbird*. My dad named it—it comes from his grandfather, who had a canoe named that as well—it was a very lucky canoe. I guess that canoe was destined for that.

The hull was carved out in Kootowis Creek, here in Tla-o-qui-aht Tribal Parks. There were two Makah apprentices, a fella named Len Bowechop and Micah Vogel. They stayed there until the hull was finished, along with my late brother Bill. My brother Bill was there the whole time. It was brought to Echachis,* and it was finished around 1991. The canoe was towed over to Neah Bay after it was finished.

HUMMINGBIRD WAS USED to capture a gray whale on May 17, 1999. It was the first successful whale hunt by the Makah Nation in over 70 years. As Nuu-chah-nulth anthropologist Dr. Charlotte Coté described it: "With that one heave of the harpoon, the Makah people had made history and revitalized a tradition central to their culture and identity."**

* Echachis Island is about 15 minutes from Tofino by boat and is a former Tla-o-qui-aht whaling site. Joe has a cabin there.

** Charlotte Coté, *Spirits of Our Whaling Ancestors*. (Seattle & London: University of Washington Press), 2010, 140.

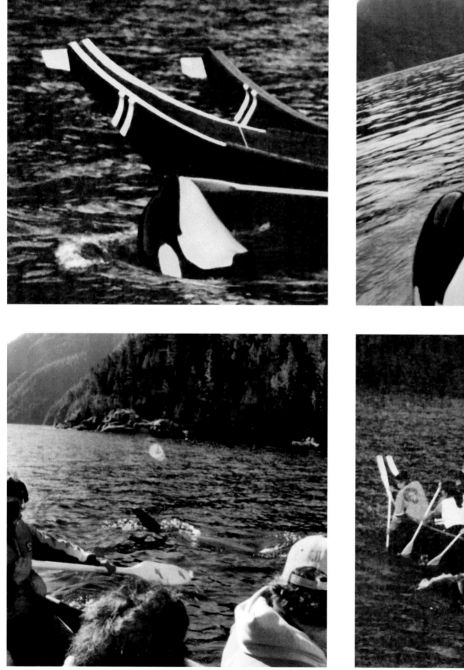
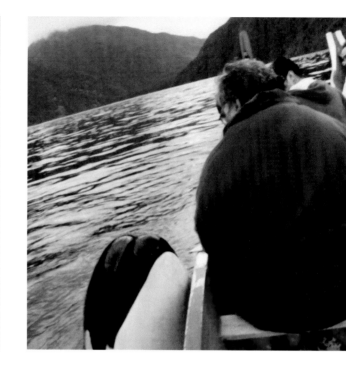
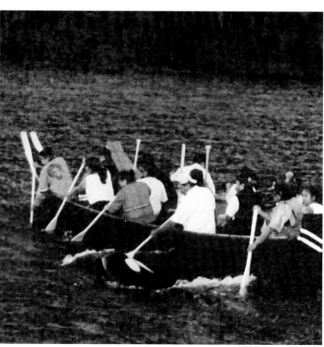

Two Canoes Carved for the Mowachaht/Muchalaht Nation and the Kakaẃin (Orca) Tsu'xiit

I MADE TWO CANOES for the Mowachaht/Muchalaht First Nation. My assistants were James Johnson (Muchalaht) and my late cousin Herb Williams (Tla-o-qui-aht). The canoes were shaped in the forest at Muchalat Lake and finished at Tsaxana behind late Chief Jerry Jack's home. The bows of both canoes are seen here, with the kakaẃin (killer whale) Tsu'xiit swimming with the canoes.

THESE TWO CANOES were used by the Mowachaht/Muchalaht people in June 2004 to prevent Fisheries and Oceans Canada (DFO) from capturing Tsu'xiit and moving him to an area near the San Juan Islands where he had been born, with the hope he would reunite with his family.* If reunification failed, DFO's rumoured backup plan was to send Tsu'xiit to live the rest of his life in a cement aquarium in Ontario. The Mowachaht/Muchalaht were dead set against seeing this happen, and a struggle between DFO and the Mowachaht/Muchalaht began.

"Our Elders and our traditions told us to stand beside Tsu'xiit just as we would one of our own, and let him know that he wasn't alone," said Chief Michael Maquinna, the son of Ambrose Maquinna. "Our interest was in letting nature take its course, and in keeping Tsu'xiit free."** Eventually the Mowachaht/Muchalaht, in their canoes, singing traditional songs including Chief Ambrose Maquinna's own paddle song, were able to

Two Joe Martin canoes made for the Mowachaht/Muchalaht with the orca Tsu'xiit, also known as Luna.
PHOTOGRAPHS COURTESY OF HA-SHILTH-SA NEWSPAPER.

* Brian Tate, "Tsuux-iit (Luna) Update." *Ha-Shilth-Sa Newspaper*, June 3, 2004.

** David Wiwchar, 2013, "Community Mourns Tsu'xiit," *Ha-Shilth-Sa Newspaper*, January 15, 2013.

entice Tsu'xiit away from the trap that DFO had set. Realizing that the Mowachaht/Muchalaht were determined to let Tsu'xiit live free, DFO abandoned their relocation strategy.

Tragically Tsu'xiit was killed when caught in the propeller blades of a large tugboat on March 10, 2006. This was just shortly after the four-year memorial potlatch had been celebrated for Chief Ambrose Maquinna. In the film *The Whale*, which documents the story of Tsu'xiit, Brenda Johnson, a granddaughter of Chief Ambrose Maquinna, stated "A lot of us knew that he was going to go. We didn't know if he would die or just leave the territory."

One of Joe Martin's Mowachaht/Muchalaht canoes travelled to the 2013 Tribal Journeys destination at Point Grenville, Washington State, in the traditional territory of the Quinault Nation.

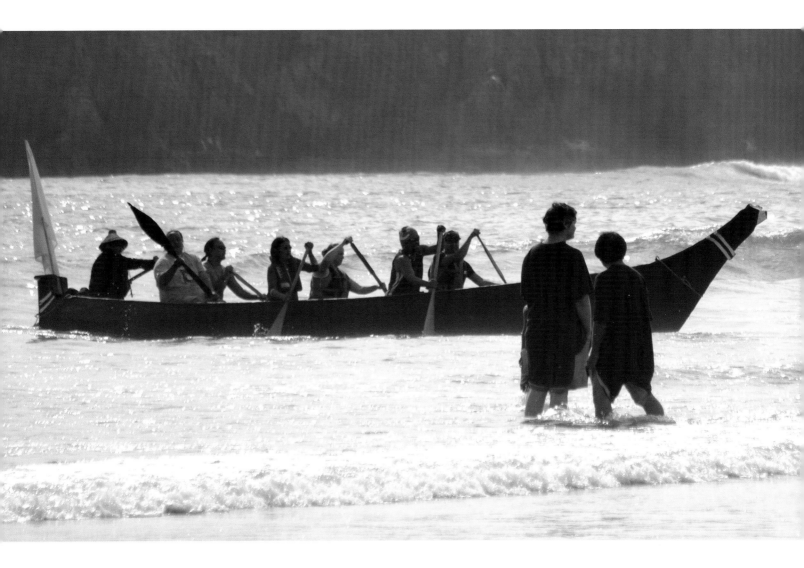

The Mowachaht/Muchalaht canoe carved
by Joe Martin comes ashore at Point
Grenville, Washington State, in 2013.
ALAN HOOVER PHOTOGRAPH.

Canoe Making and Reconciliation

Coast Salish Style: Hɛhɛwšin (Way Forward) Reconciliation Canoe

IN 2017 I WAS ASKED by a group of non-Indigenous people from the Powell River area to lead the carving of a Coast Salish style canoe. They wanted to give a traditional dugout canoe to the Tla'amin Nation in the spirit of healing and reconciliation between the communities.

The crew that worked with me carving the canoe were Alvin Wilson, Sherman Pallen, Phil Russell and Ivan Rosypskye.

THE HɛHɛWŠIN (Way Forward) Reconciliation Project was guided by John Louie (yaʎwum) and Cyndi Pallen (*čune*) of the Tla'amin Nation. They worked with Phil Russell (kʷunanəm) to bring awareness to the wider Powell River community of the effects of colonialism and of the current and of the historical and current abuse that still impacts communities today.

The carving crew: Sherman Pallen, Joe Martin, Phil Russell, Alvin Wilson and Ivan Rosypskye. Powell River, 2017.
ALEX SUTCLIFFE PHOTOGRAPH.

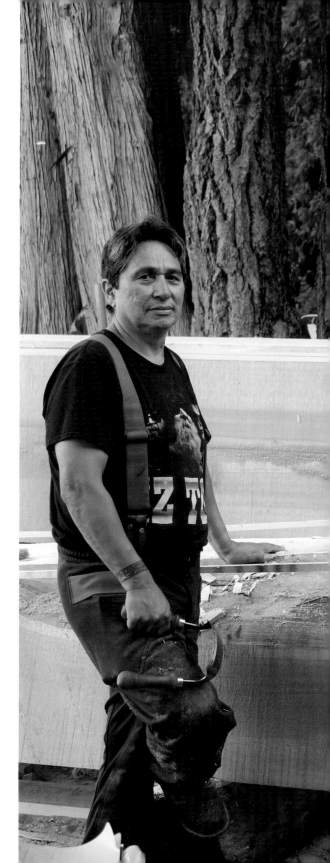

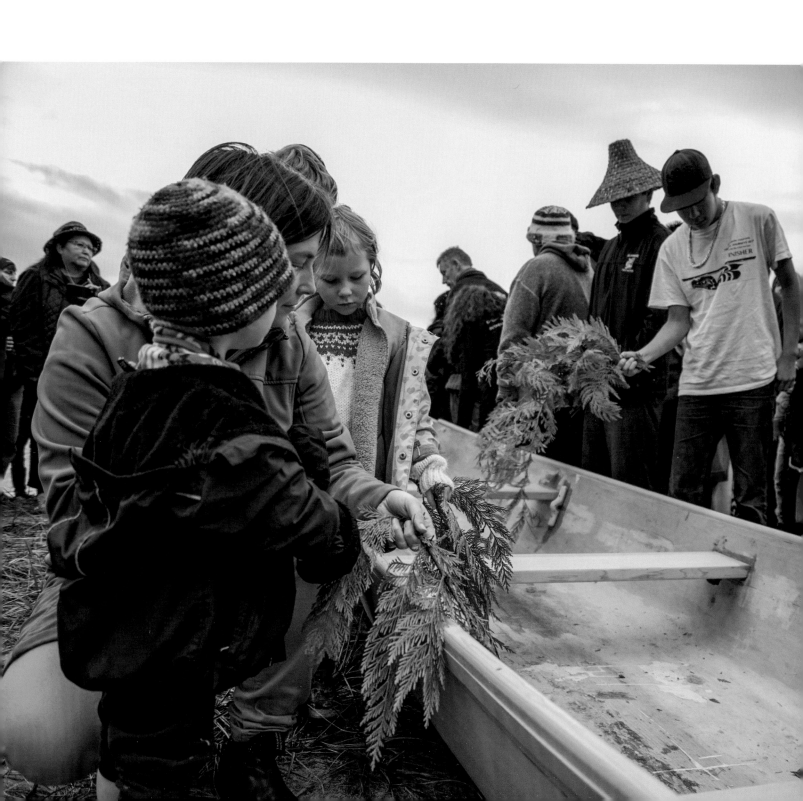

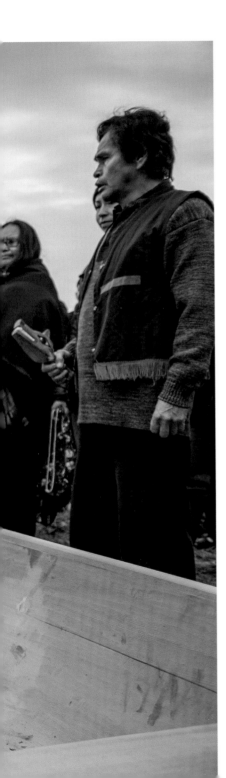

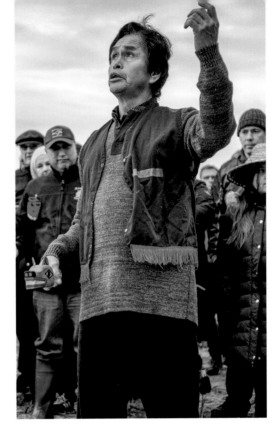

(*left*) Members of the community "cleaning" the Hɛhɛwšin canoe with red cedar boughs before its first launch at Willingdon Beach, Powell River.

PHIL RUSSELL PHOTOGRAPH, 2017.

(*above*) I am doing a ceremony blessing the canoe and thanking the forest for the red cedar. Launch of the 26-foot-long Coast Salish style canoe made for the Hɛhɛwšin (Way Forward) Reconciliation Canoe Journey Project at Willingdon Beach, Powell River, November 2017.

PHIL RUSSELL PHOTOGRAPH.

The unpainted Hɛhɛwšin canoe is first launched at Willingdon Beach, Powell River, November 18, 2017.
PHIL RUSSELL PHOTOGRAPH.

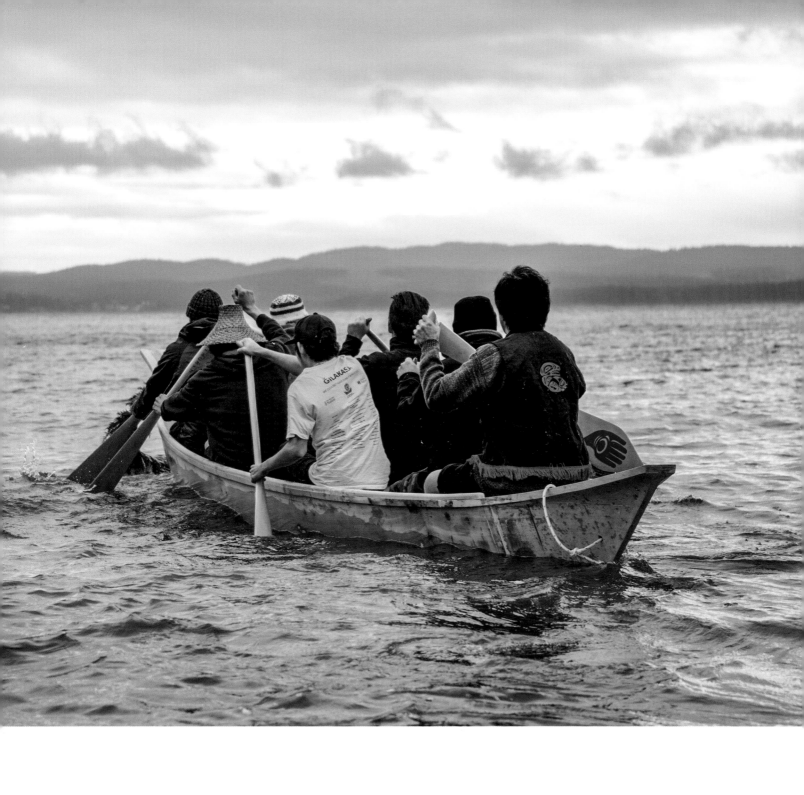

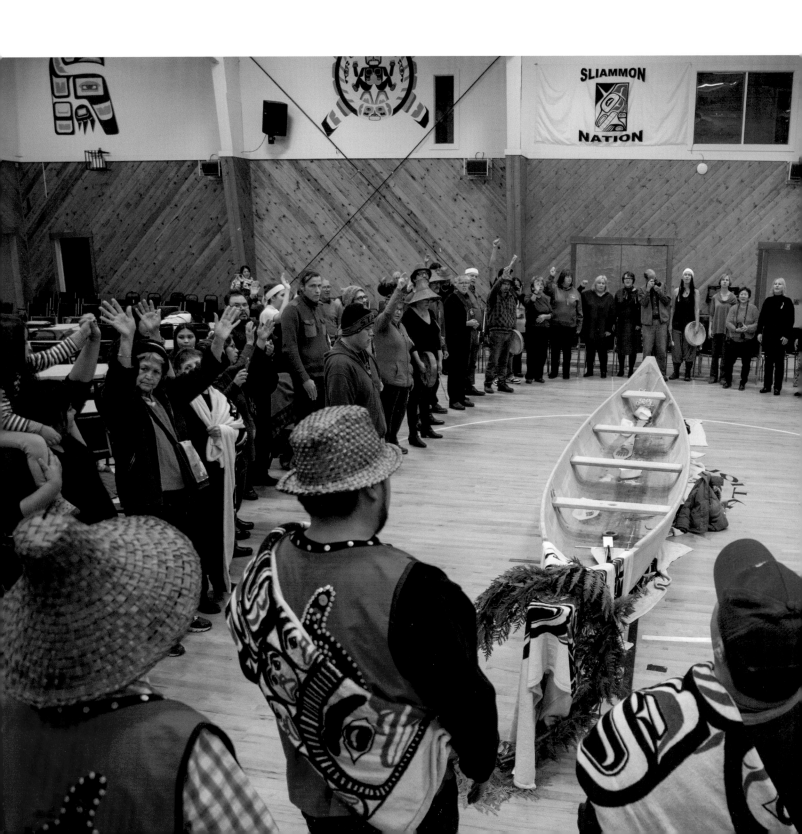

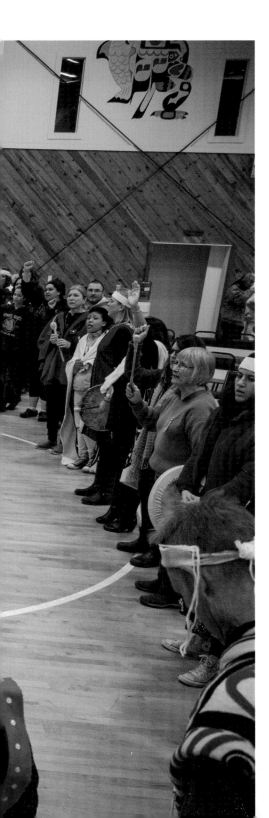

"On behalf of the Tla'amin Nation Government and our Community; I want to say that we very much appreciated the hard work and dedication that the Hehewshin group volunteers did leading up to this incredible day. Thank you! Che cha nah tahn nah pesht!"

—MESSAGE FROM THE HEGUS (CHIEF)
CLINT WILLIAMS, QUOTED IN *NEHMOTL*,
THE NEWSLETTER OF THE TLA'AMIN NATION,
DECEMBER 2017.

The Tla'amin Nation accepts the gift of the Hɛhɛwšin canoe from the people of Powell River. November 18, 2017.
PHIL RUSSELL PHOTOGRAPH.

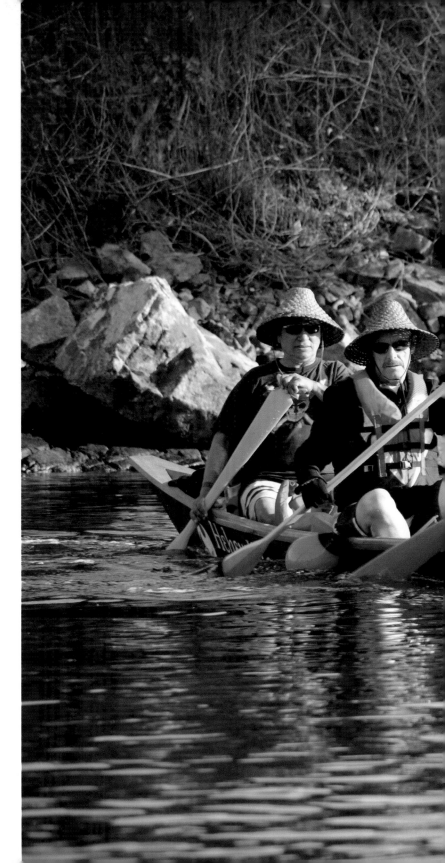

The Hɛhɛwšin canoe completed, with painted design by Sherman Pallen, en route to Klahoose First Nation. The pullers are, from left to right: Sherman Pallen (skipper), Phil Russell, Joel Benson, Zoe Ludski, Nikole Pielle and Cyndi Pallen.
ALEX SUTCLIFFE PHOTOGRAPH, 2018.

According to Tla'amin citizen Scott Galligos, the Hɛhɛwšin canoe is far more than just a conversation between Indigenous and non-Indigenous people. It illuminates traditional teachings and cultural history. "This canoe is going to help heal," said Galligos. "It's medicine to our people."*

* Galligos quoted in David Brindle, "Community Celebrates Reconciliation Canoe Completion," Powell River Peak, November 22, 2017. https://www.prpeak.com/community/ community-celebrates-reconciliation- canoe-completion-1.23101137

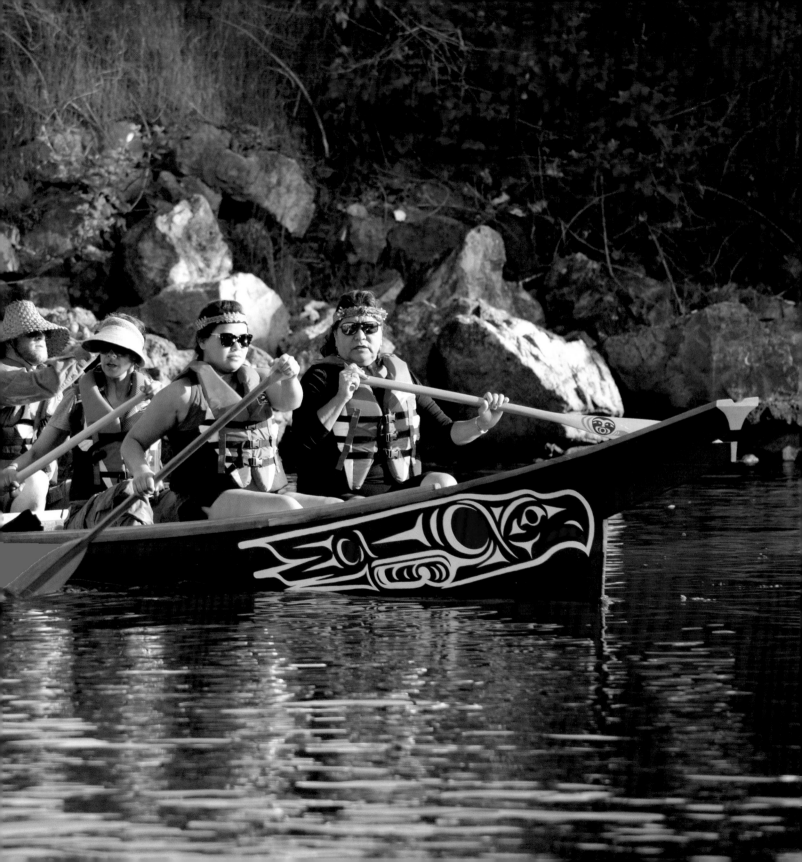

The Salt Spring Island Canoe

I MADE A 32-foot-long Coast Salish style canoe as part of the Xwaaqw'um Project. The purpose of the canoe project was to celebrate Coast Salish culture and strengthen relations between settlers and Quw'utsun (Cowichan) First Nations people. The project began in 2015 in the Tla-o-qui-aht Tribal Parks forest and was finished at Burgoyne Bay on Salt Spring Island. I was assisted by Joe Akerman and Christopher Roy. Over the course of the carving project, many schoolchildren came to the carving site, met with me and the other carvers, and tried their hand at tools used in smoothing the hull. The canoe was launched in September of 2018.

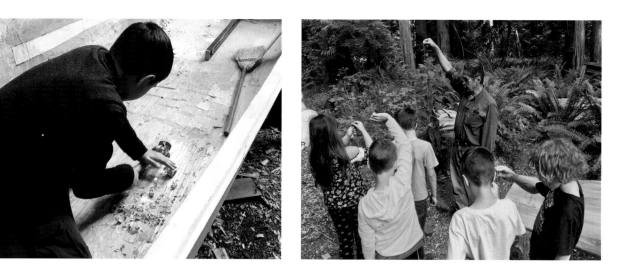

Fernwood Elementary student trying his hand at smoothing the inside of the canoe at Burgoyne Bay, 2018. CHRISTOPHER ROY PHOTOGRAPH.

Joe showing children how to make a plumb line, 2018. CHRISTOPHER ROY PHOTOGRAPH.

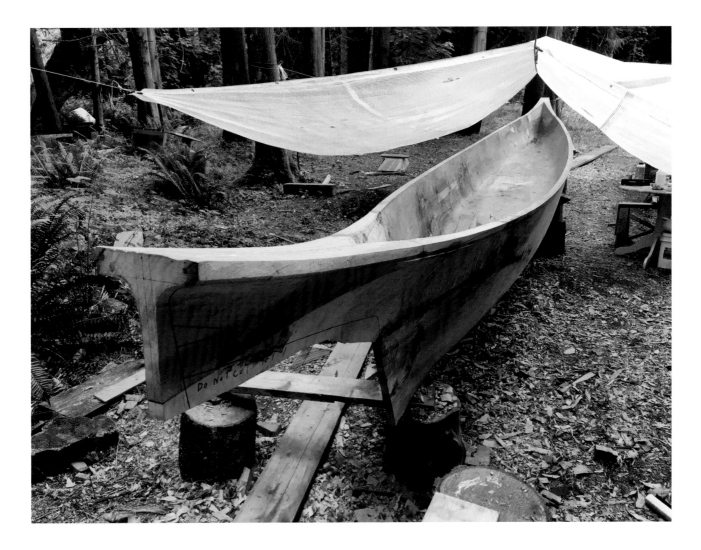

The Salt Spring Island canoe, *Xwaaqw'um*, nearing completion, but not yet steamed. Note the outline for the shape of the bow, which is not completed.

JOE MARTIN PHOTOGRAPH, 2018.

THE CANOE WAS LAUNCHED in September of 2018 (next page) in a ceremony led by resident Elder Tousilum (Ron George). The canoe was then gifted to Tousilum on behalf of the project by Quw'utsun Elder Luschiim and Joe Akerman in recognition of his service to the community.*

* Gail Sjuberg, "Many Hands Carry Xwaaqw'um Canoe," Gulf Islands Driftwood, January 3, 2019. https://www.gulfislandsdriftwood.com/island-life/many-hands-carry-xwaaqwum-canoe

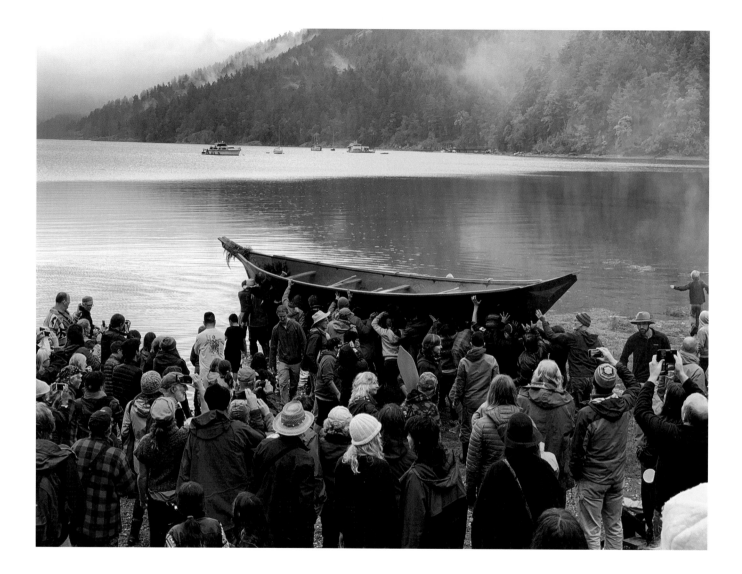

The Salt Spring canoe is launched at Burgoyne Bay, September 2018. CHRISTOPHER ROY PHOTOGRAPH.

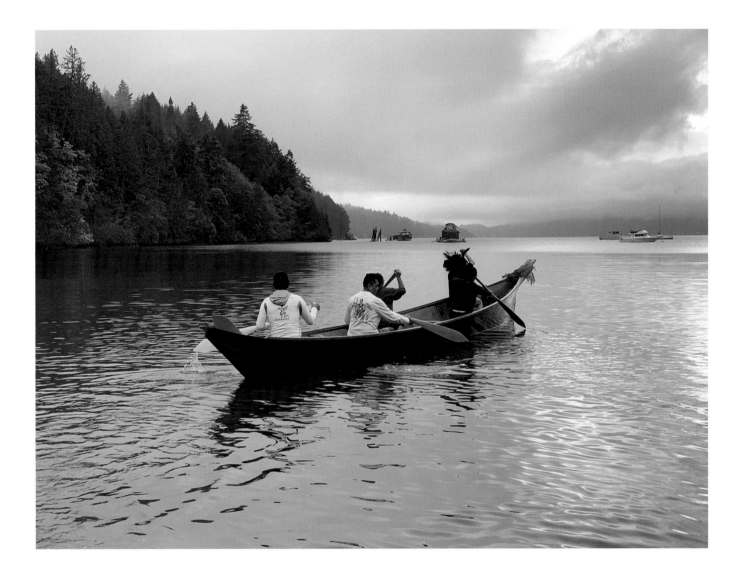

Xwaaqw'um in Burgoyne Bay, Salt Spring Island, September 2018. CHRISTOPHER ROY PHOTOGRAPH.

Making a Western Red Cedar Dugout Canoe

Selecting the Tree: Traditional Knowledge

IN ORDER TO MAKE A CHAPUTS, a forest which has been tended for millennia by Indigenous Nations is needed, where a fine quality red cedar with straight grain can grow protected by cultural protocols over many generations. Knowing where to find suitable trees for the size of chaputs needed is essential. There are areas on the mountains where the red cedar grows the best. For example, there are some bays which are not as affected by the different winds as are places higher up on the mountains. If you look on the mountains going by canoe or by car, you will see areas where there are more dead tops, and some areas where there are none. Those areas where there are many dead tops are usually where it is exposed to high winds, which sometimes can blow hard for days. If it is blowing 30 knots along the coast, it may be blowing much harder in the inlet, where the wind has to funnel through the mountain valleys and islands. This can lead to red cedar trees that are hollow, as the high winds which have lasted for days have blown off all the leaves, leaving bare branches and dead tops as a result. Former weather conditions along the coast must also be considered.

At one time it was colder here in the winter, leaving 10 inches of snow on the ground and in the trees. It would then very quickly warm up, with rain falling, causing the snow to become very heavy, breaking branches in high winds, which would then lead to rot at the centre of the tree.

Once a tree is selected for the size of canoe needed, a square test hole is carved all the way to just past the core of the tree to see if the wood is sound—no rot or cracks! The test hole side of the tree would be carefully selected, as that is the direction the tree is to fall.

Western red cedar tree in a Tla-o-qui-aht garden. JOE MARTIN PHOTOGRAPH.

An important consideration is to know what side of the tree had more exposure to sunlight when it was hundreds of years younger and may have had branches broken off as a result of many different storms, e.g., wind, snow. After a branch has broken off a tree, it may stick out for many years until the red cedar grows over all the branches which had been broken off. So now when we see this apparent straight red cedar, it may have hidden knots deep inside the really "nice" looking wood. The next thing to do is carefully look around the base of the tree where the roots turn into the tree to look for holes or rot. These are reasons why it is important to be there when the tree is selected.

Selecting the Tree According to Cultural Protocols and Natural Law

THERE ARE OTHER CONSIDERATIONS to be made now that the tree has been selected. It is important to be aware of all things close to this red cedar tree. For example, is there an eagle or other bird's nest, or wolf or bear dens? Or is it close to a salmon stream? If so, then it would not be allowed to cut a tree anywhere near any of these creatures put here by the Creator. If one were to cut this red cedar too close to any eagle nest or bear den, it would be the Creator who would take this as an offence, and great harm could come to your whole family, so it was very important to be aware of all your surroundings. This is what my father and grandfather taught me, to always be respectful, as Nature will provide our needs, but not our greed!

Once the tree is felled for a certain size canoe, then the work begins! If a canoe is to be about 32 feet long, the log needs to be about 5 to 6 feet in diameter at the butt, which has been "long butted" to get away from as much bark seam as possible.

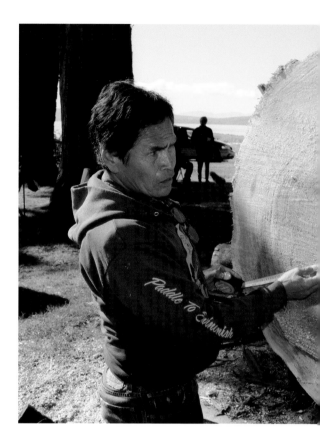

Joe Martin measuring the diameter of the butt of the log to determine how much to cut off for the length of the canoe to be made. Willingdon Beach, Powell River, in Tla'amin territory, 2017. PHIL RUSSELL PHOTOGRAPH.

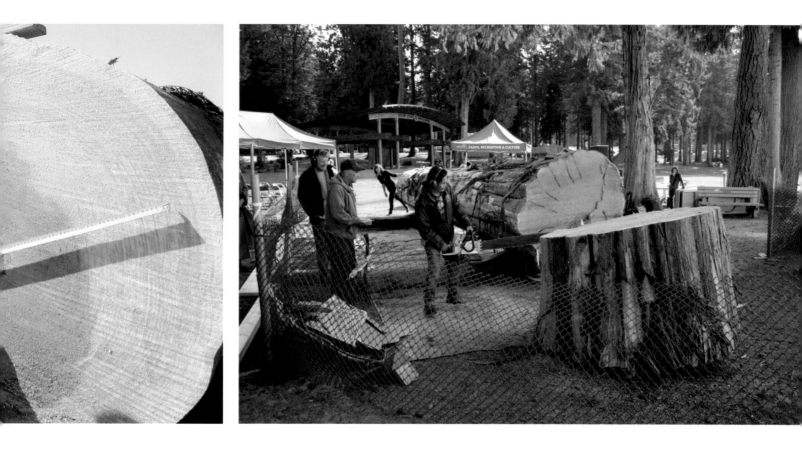

Joe Martin cutting the butt from a canoe
log. Willingdon Beach, Powell River, 2017.
PHIL RUSSELL PHOTOGRAPH.

When the log has been bucked (cut) to its final length, and the butt-cutoff removed (see previous page), one may see that the core of the log is off centre. This is because of the direction from which the tree received a lot of sunlight. That side of the tree will have grown a lot of big branches on it, making the core off centre. This side of the apparently nice straight red cedar may have hidden knots inside, which will not be exposed 'til carving begins. Ideally a canoe log is a clear, solid red cedar with just small cracks on the butt end or the top end. Now the log should be rolled with the side that was toward the sunlight, the side with most branches, up.

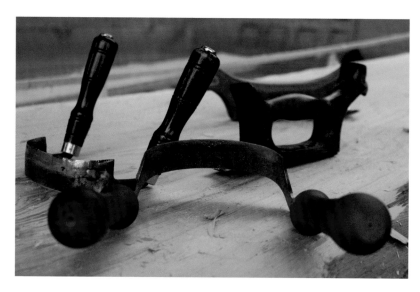

Joe Martin's draw knives and D-adzes.
PHIL RUSSELL PHOTOGRAPH, 2017.

From this point, carefully looking at any defects, consider how the hull will come out of this log. Once this is determined, carefully hang a rock down each end on a string. This will determine the bow and stern stems. On a Tla-o-qui-aht canoe the bow is slanted about 40 to 45 degrees, and the stern almost straight up. Once the bow and stern stem is determined, the only place to level the hull is from the stern, because it is almost straight up.

The next step is to begin carefully shaping the sides of the hull. In the former days the ancestors had only stone, bone and fire to do all this work and, after European contact, axes (see pages 53–55). Today I use a well-maintained and sharpened chainsaw with the appropriate length bar with an Alaskan sawmill kit (see facing page, left), two different axes, a single bit and a double bit, steel and plastic wedges, a sledgehammer and four different D-adzes, two elbow adzes, two draw knives, four different hand planes, and several chisels of different sizes and shapes.

With the core offset, take a measurement to determine the centre of this log on both ends. Use a straight edge to draw a line across about one and a half inches above the core. Now roll the log till this line is straight using a plumb line attached with a suitable nail, and wedge or properly support the log so it will not move.

A long, bright-coloured strong string is strung between two end plates of two-by-sixes 12 inches long, levelled carefully, placed and nailed onto each end of the log. The string is placed carefully on each edge of the end-levelled board and strung tightly, so as to not have any sagging, as a guide to placing the 3/8-by-6-inch lag screws.

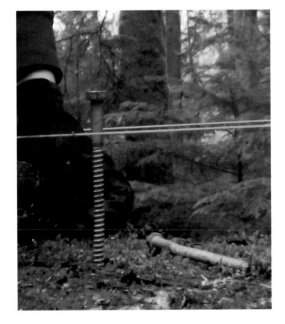

Beginning to place lag screws into the log to set up an Alaskan sawmill kit. Hitacu (Ittatsoo) village, 2018. JOE MARTIN PHOTOGRAPH.

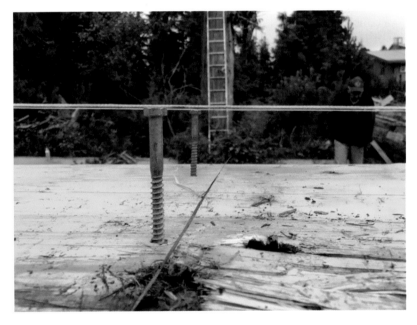

This image shows the lag screw heads just below the twin strings. Hitacu (Ittatsoo) village. JOE MARTIN PHOTOGRAPH, 2018.

Begin placing the lag screws two feet apart from the end board all the way to the other end of the log, just inside of the string, with just enough space for clearance for the head of the lag screw just inside the string. Looking across from one levelled, parallel string to the next, the head of the lag screw should be visibly touching the string at the top of the lag screw, with two lag screws placed two feet apart and properly adjusted. This will support the 2-by-12-by-16- or 18-foot guide plank to run the Alaskan mill on, making a perfect cut from end to end.

Thirty 3/8-by-6-inch lag screws are needed for this, and they can be hammered in with a good single-bit axe or a smaller sledgehammer, then adjusted with a proper box-end wrench to the proper height.

This can be done perfectly, greatly reducing much work if done correctly. Once this is all set up, take a 2-by-12-by-16- or 18-foot plank—although even a 10-foot will do, but it means that the plank must be slid along more than once. At first the plank must stick out about 12 inches past the end of the log to properly start the cut with an Alaskan mill. The mill must be properly adjusted and tightened to clear all the 6-inch lag screws once the guide plank is put on, so as not to cut the lower ends of the lag screws pounded into the log (see previous page).

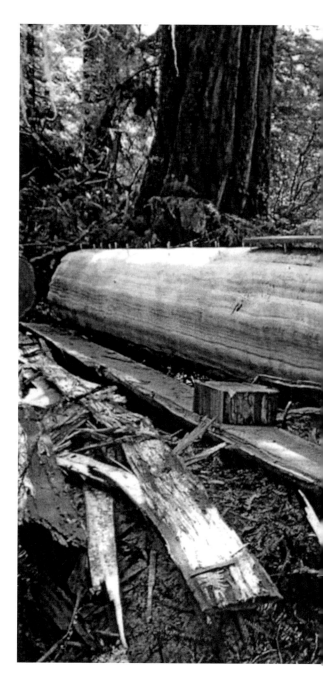

Log with guide board on lag screws for the Alaskan chainsaw mill. Bill Martin and his dog Abby. Tla-o-qui-aht Tribal Parks. JOE MARTIN PHOTOGRAPH, 2015.

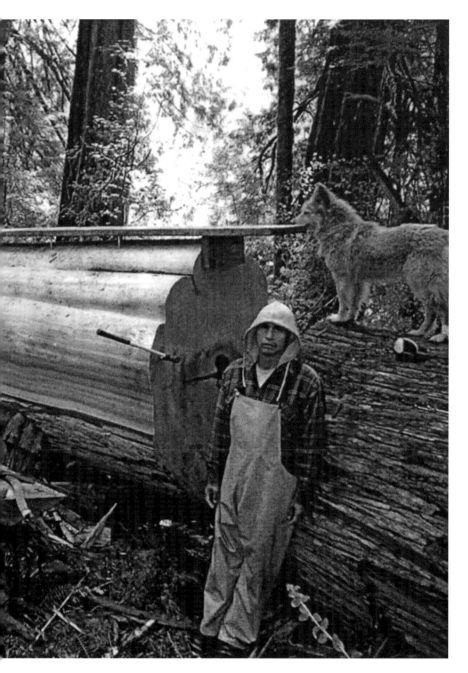

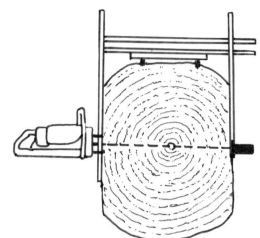

A schematic diagram illustrating how an Alaskan sawmill kit with long enough guides can cut through the core of the log to produce two edge-grain canoes.
LENI HOOVER DIAGRAM.

The Alaskan chainsaw mill is set up to remove a slab from one side of the log. The log is then turned 180 degrees, and the slab on the other side is milled off so the first cut winds up on the bottom with the same nail removed and moved to the top. Adjust and wedge or support the log so it is plumb and will not move while the second side is Alaskan milled.

Once this is done, roll the log with the two sides cut off so they are plumb straight up. Measure the centreline where the stern and bow stem will be. Carefully mark ½ inch on each side of the established centreline at both ends of the hull, which should be straight up plumb. Very important! This step established the thickness of the bow and stern stems, which will vary depending on the size of the canoe being made.

In this photograph the boards nailed on both sides are set up to guide the saw. I used this technique because I didn't have guide bars long enough to have the Alaskan sawmill run with a guide plank, as seen on top of the log in pages 54–55.

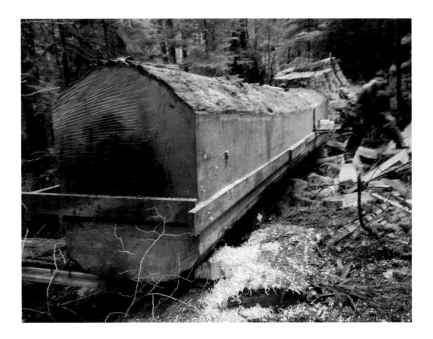

Cutting the log in half using two-by-sixes nailed to the vertical sides of the log to guide the power saw.
JOE MARTIN PHOTOGRAPH.

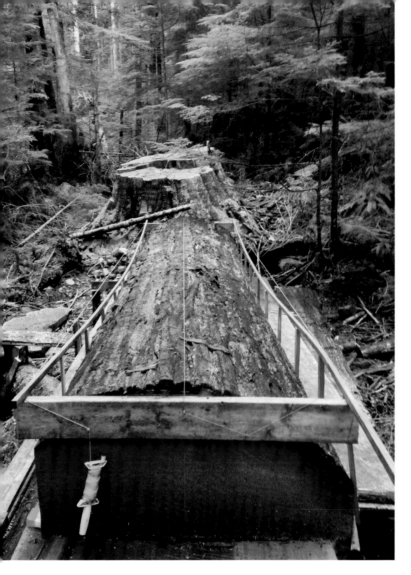

Sheer line guides and centre line in place. The bottom of the canoe will be near the centre core of the log so the hull will be edge grained, rather than flat grained as when the bottom of a canoe is near the outside edge of a log. JOE MARTIN PHOTOGRAPH.

Other items needed are several wedges, which could be cut on a table saw, ⅜ of an inch thick and 3 or 4 inches wide, 5 inches long or more, and slightly tapered on one end. These wedges are inserted into the cut opposite of each other as the saw moves toward the other end of the log.

Also include four flat staples made out of old car springs or some 2-inch-by-¼-inch flat steel, 4 inches long with each end bent down 1½ inches and slightly sharpened to be hammered in on the end where the chainsaw begins its cut, as a staple. This will keep the slab from moving. Just before the saw cuts through, separating the log into huge slabs, insert a falling wedge opposite each other (on either side of the cut), hammered in slightly to prevent the saw from pinching the chainsaw bar as the cut gets finished.

Once the cut is started, with the bar just buried into the log, the two flat staples are driven in to support the slab and to prevent it from moving. The precut wedges are placed parallel to each other every four or five feet to prevent the heavy slab from sagging.

Now that the log is sliced in half, it is time to move the heavy slab from the top.

Take two plastic faller wedges and drive them all the way in the middle of the slab. What you will find is that two persons can, with some effort, move the slab swinging each end opposite each other, then finally sliding one off the other. This must be planned so as to make the work easier. This may make two canoes, one out of each slab. With the chosen slab, with the bottom down, put in a nail and hang a plumb line, then level accordingly and support where needed, so that the slab will not move.

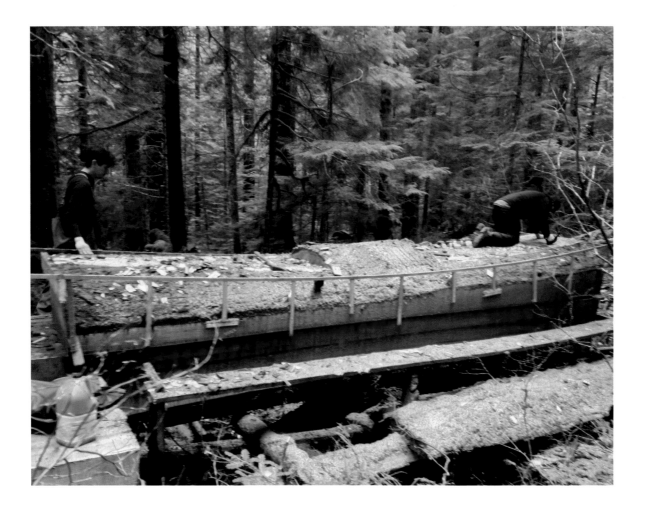

The next step is to set up to take out the sheer line, which is the top from the bow to stern. The bow is about five or six inches higher than the stern. Take a 2-by-6 two inches or a bit longer than each end. The ends must stick out at least one inch on each end. This must be carefully levelled at the front end, 30 inches or a bit more. Put one more on the stern end, which will be carefully levelled with ends sticking out at least one inch. This 2-by-6 must be around 26 inches high from the bottom (see pages 56 and 57).

In this photograph we are beginning to remove the wood above the sheer line with axe and adze after chainsaw cuts were made across the width of the log. (Note that sheer line guides are in place.) As the bottom of the canoe will be at the centre of the log, the canoe will be edge grained. Tla-o-qui-aht Tribal Parks, 2014. JOE MARTIN PHOTOGRAPH.

Timber in Tla-o-qui-aht Tribal Parks comes from X̣aʔuukʷiʔatḥ (Tla-o-qui-aht) ancestral forests. Dad's canoe carving is a continuation of exercising rights and responsibilities in relationship with unceded X̣aʔuukʷiʔatḥ territory.

—GISELE MARTIN, 2021

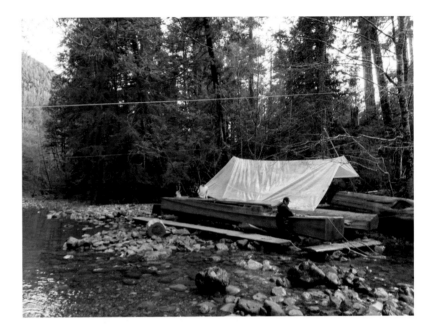

(*above*) This log was a windfall on the Upper Kennedy River (Tla-o-qui-aht Tribal Parks) that was transformed into the Coast Salish style canoe seen on pages 45 through 47. CHRISTOPHER ROY PHOTOGRAPH, 2018.

(*below*) I used the power saw to remove excess wood from the top of the log down to the sheer line. The blue tarp catches the sawdust from contaminating the salmon-bearing stream. I used vegetable rather than petroleum oil to lubricate the chainsaw. Because of large knots and rot, the canoe (see pages 47 and 48) had to be flat grained. Tla-o-qui-aht Tribal Parks. CHRISTOPHER ROY PHOTOGRAPH, 2018.

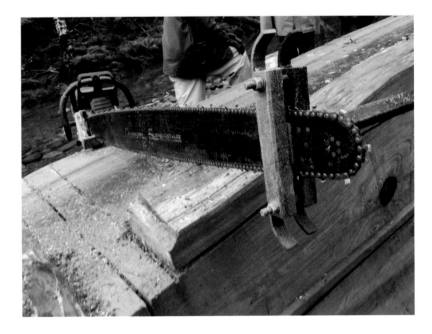

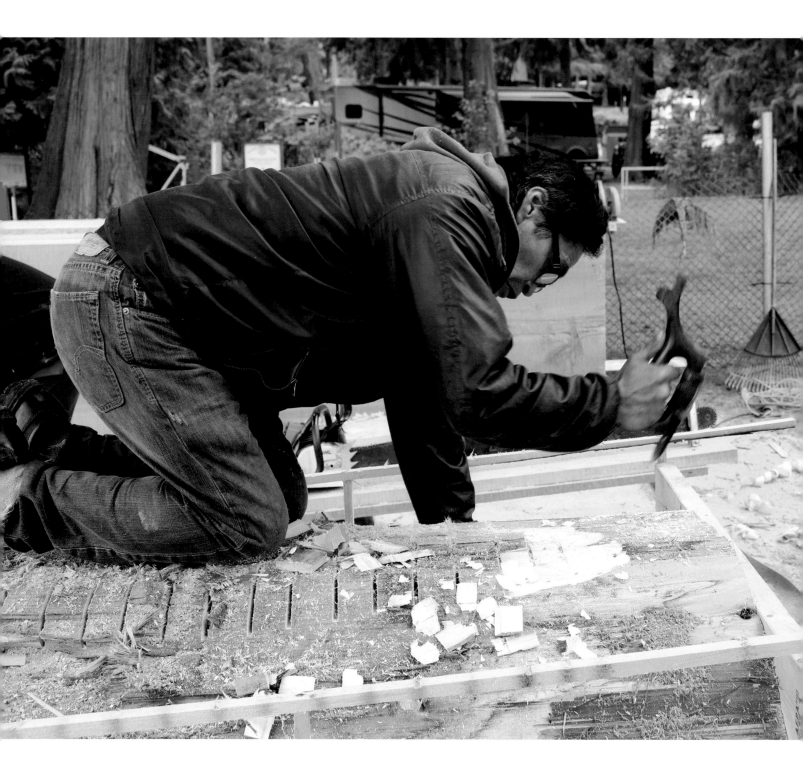

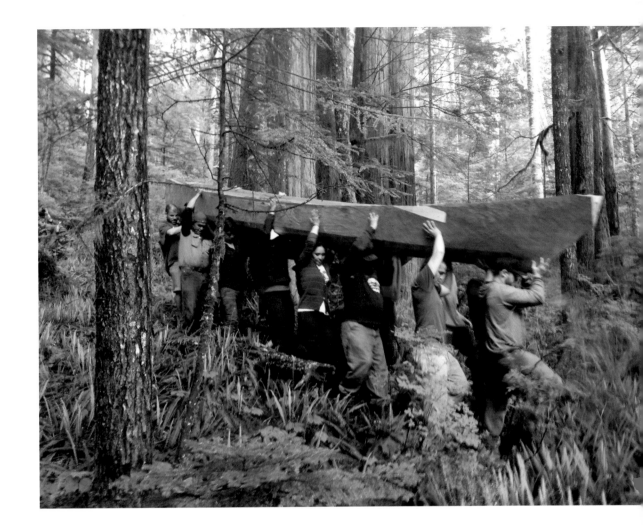

(left) I am adzing down to the sheer line marked by the sheer line guides. The parallel saw cuts speed up the adzing. Powell River. PHIL RUSSELL PHOTOGRAPH, 2017.

(right) Carrying a partly finished canoe out of the bush. JOE MARTIN PHOTOGRAPH.

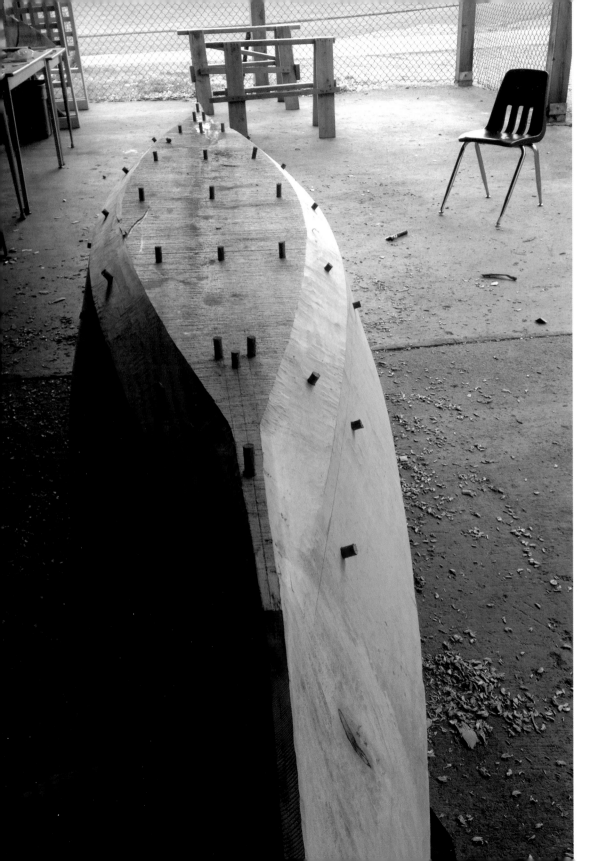

Depth hole plugs, before they are pounded in, on the outer surface of a 14-foot personal-size canoe. March 3, 2014.

JOE MARTIN PHOTOGRAPH.

After finishing the outside of the hull, the next step is to place depth hole plugs across the hull. Blue chalk powder is put in the holes, and then dry red cedar plugs are placed in the drilled holes. The length of the plugs depends on the size of the canoe. The plugs are spaced approximately two feet apart going toward the stern and bow. The spacing between each plug across the width of the canoe varies by canoe size: as much as 10 to 12 inches on the larger canoes and as little as 6 to 8 inches on the smaller canoes. The plugs are two inches long on the bottom and one inch long on the sides. On a 30-foot canoe the plugs are 2½ inches long on the bottom and 1¾ inches on the sides.

Red cedar depth hole plugs on the canoe hull's inner surface. Canoe made for the Yuułuuʔiʔath (Ucluelet First Nation) in 2018.
ALAN HOOVER PHOTOGRAPH.

Red cedar depth hole plug on the canoe hull's outer surface. Ideally the grain of the plug should be at 90 degrees to the grain of the hull so as not to promote splitting of the hull. Joe Martin's studio, Načiks, 2020.
ALAN HOOVER PHOTOGRAPH.

Steaming a Canoe

THE STEAMING OF THIS CANOE, made for the Yuułuuʔłʔath (Ucluelet First Nation), took place in November of 2018. The team that carved it included Raymond Haipee, Jack Touchie, John Tutube and Donald Williams Jr. Many others assisted in the steaming, including Carl Martin and Gary Martin.

I FEEL IT IS IMPORTANT to steam canoes that are over 20 feet or, what's that, about 7½ metres or so. When canoes are longer than that, what happens if they are too straight on the bottom is it is very hard to steer them. They go too straight, and it is very difficult to make them turn. So what must happen is that the bottom must have a curve with the ends higher than the middle, which makes the canoe easier to turn. What happens when you make the bottom curved, it makes the sides wide. You set the canoe up so it has to be level this way (lengthwise) and also level that way (across its width), and the best place to do it is really the beach, which is already level. Set it up on two blocks but not on the ends. It must sit on the blocks, and they can't be right on the ends of the canoe.

Sketch showing the location of the hot rocks over wooden supporting blocks, the traditional use of long, tapered wedges to bring up the ends of the steamed canoe, and the pit dug into the sand under the middle of the canoe. SKETCH BY LENI HOOVER AFTER JOE MARTIN.

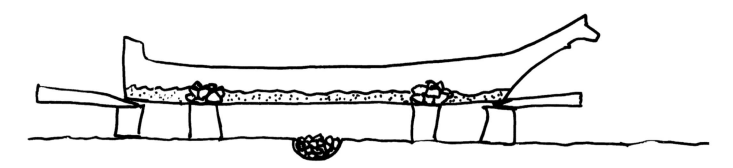

What you do on a large canoe, about 10 metres, you put about 20 centimetres of water in the bottom of the canoe. And this should sit level. What you must do when you have about 150 rocks about baseball or softball size is put them in a fire that has been built up to make them red hot. After they're red hot, you pull them out of the fire and put them inside the canoe on top of where the supports go. The rocks have to go there because that's where all the weight is. And also underneath in the sand—you must dig a hole underneath the canoe. All the rocks that break, you put in the hole.

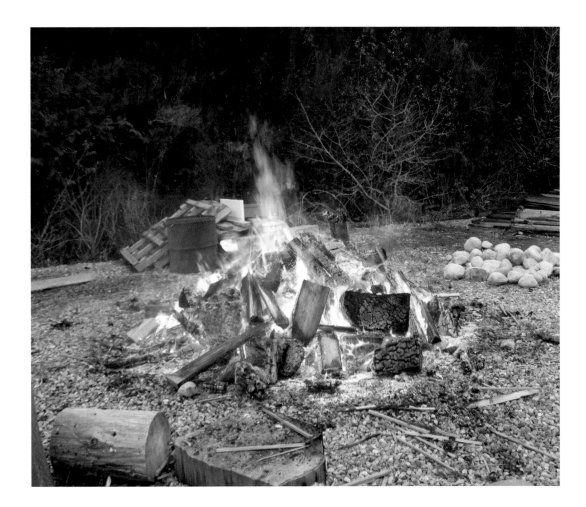

Rocks being heated before steaming the canoe. Note the extra pile of rocks in the background.
ALAN HOOVER
PHOTOGRAPH.

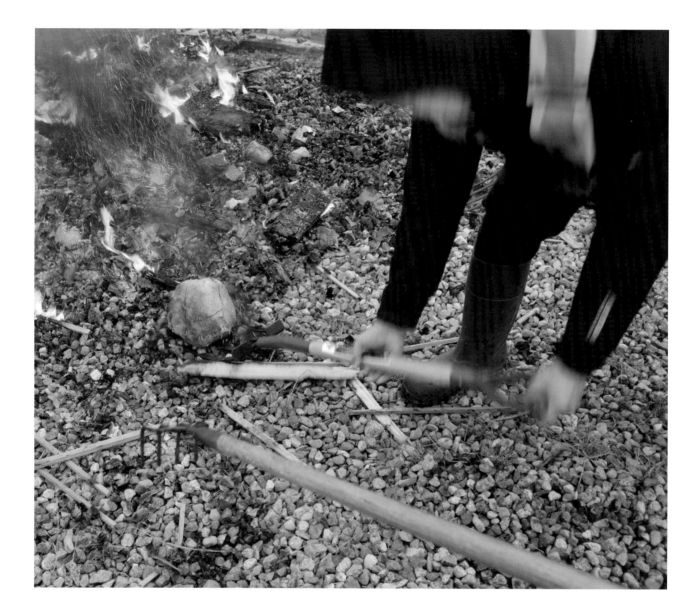

Moving the rocks from the fire to the canoe. ALAN HOOVER PHOTOGRAPH.

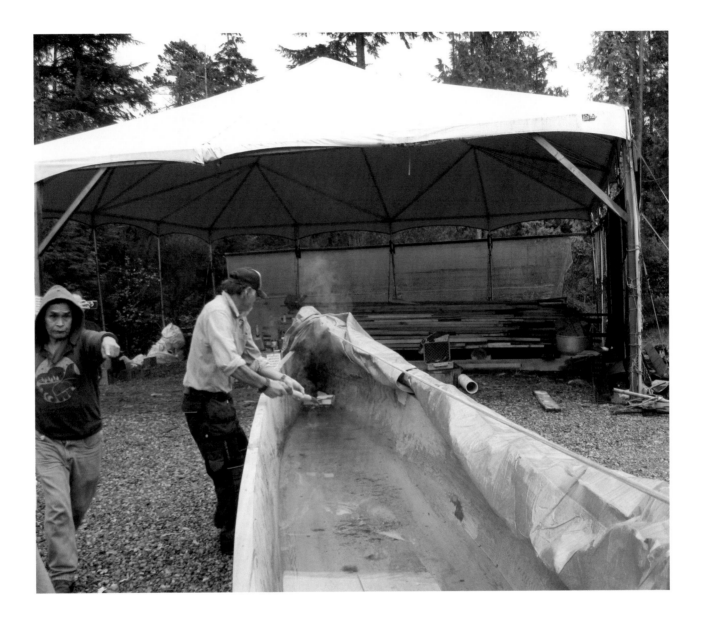

The first placing of rocks in the canoe, which has about six to eight inches of water in it. I am pointing out to my helpers that rocks need to be placed closer to the centre of the hull above the blocks on which the canoe is supported. Ray Haipee places rocks in the bow of the canoe. ALAN HOOVER PHOTOGRAPH.

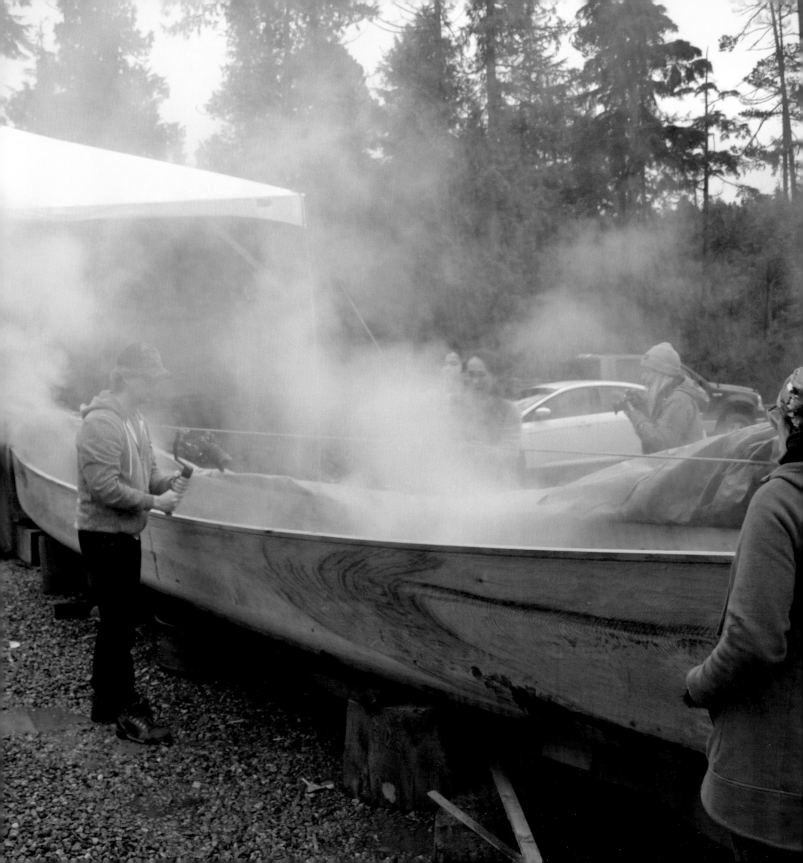

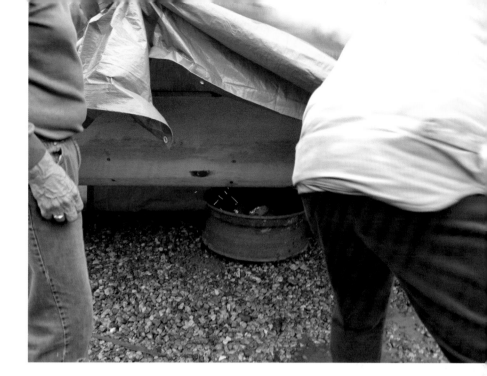

(*facing*) Steam rising above the support blocks right and left. The canoe is being steamed on hard ground, and the truck-wheel rim is a substitute for a hole dug into beach sand. ALAN HOOVER PHOTOGRAPH.

(*top right*) Red-hot rocks in the truck, wheel rim beneath the middle of the hull. Water is thrown on the rocks and the steam that is produced softens the wood.
ALAN HOOVER PHOTOGRAPH.

(*bottom right*) I am throwing water on the hot rocks in the wheel rim to put more steam on the bottom of the hull.
ALAN HOOVER PHOTOGRAPH.

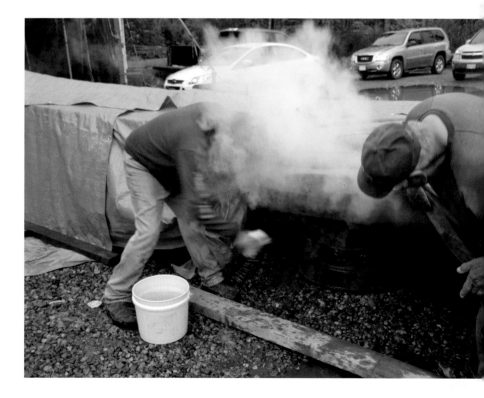

Then you cover the whole thing. In the former days our people would cover it with red cedar bark mats, but today we use a tarp, a plastic tarp. You go to the hardware store and buy it. Cover the whole thing and you seal it all in and leave it for about 45 minutes.

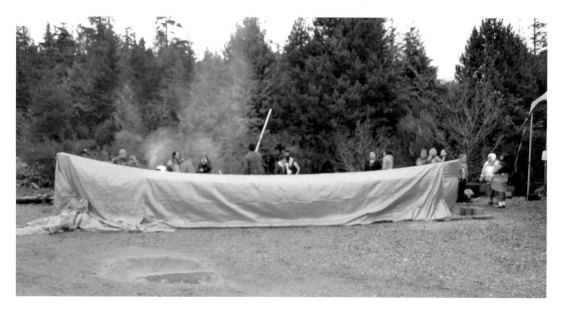

Canoe completely covered with tarps. ALAN HOOVER PHOTOGRAPH, 2018.

Occasionally you can lift up the tarp and splash water on the rocks that are underneath and that gets very hot. It gets hot enough that it will melt the tarp sometimes. You must leave it for about 45 minutes if it's hot enough. And it's important that there's no wind, because the wind will blow and will cool it off really quickly.

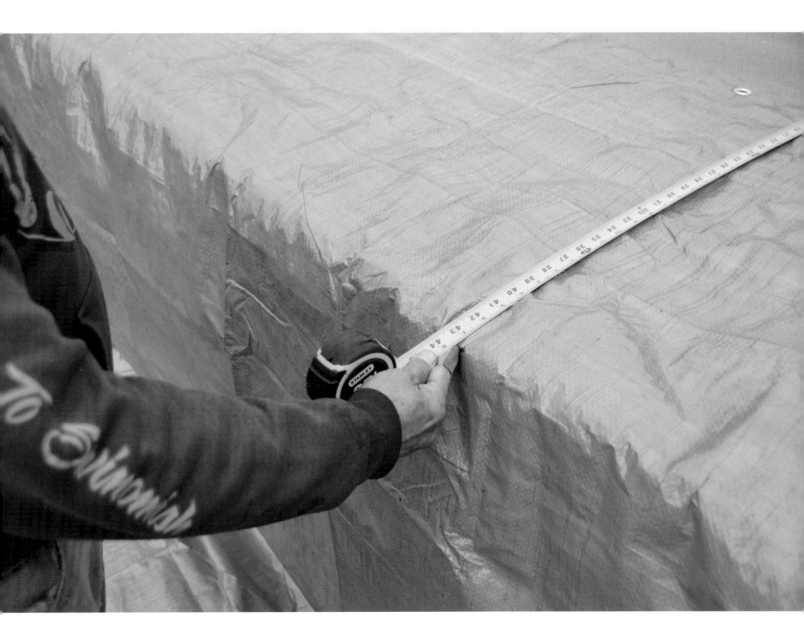

I am measuring the width of canoe at 43½ inches. ALAN HOOVER PHOTOGRAPH, 2018.

Once it is hot enough, what you do is you lift on the stern and the bow right at the very tips. You lift it, and what happens is that it opens like that. Joe demonstrates by holding a folded piece of paper and lifting up both ends, which makes the middle open wide. And you only lift it so much, because if you go too far it can crack.

Scissor jack at bow. These jacks are an alternative to the long, slim wedges that my grandfather used (see page 64).
ALAN HOOVER PHOTOGRAPH.

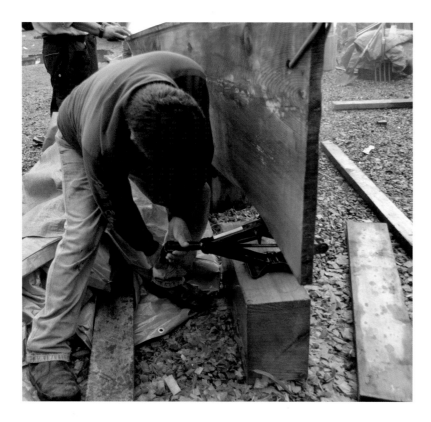

I am using an automobile scissor jack to raise the stern of the canoe.
ALAN HOOVER PHOTOGRAPH, 2018.

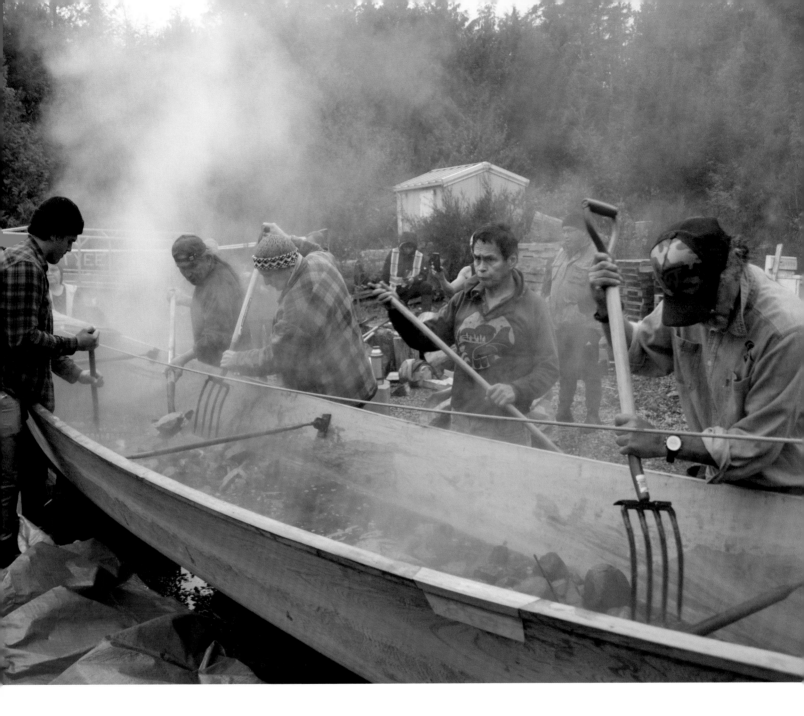

We are all moving the rocks toward the centre of the canoe to add weight to help in raising the ends. Ray Haipee is to the viewer's right. ALAN HOOVER PHOTOGRAPH.

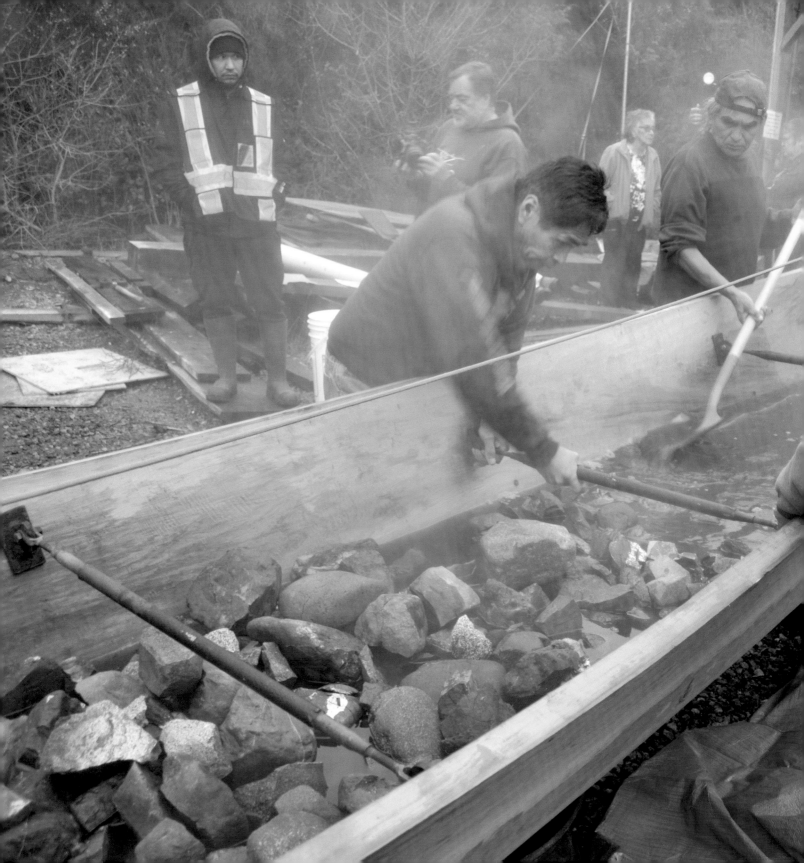

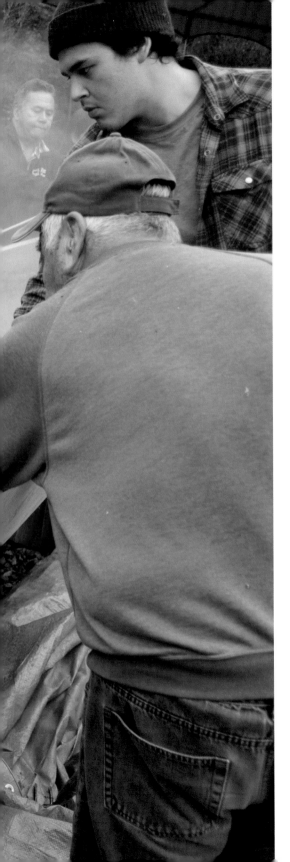

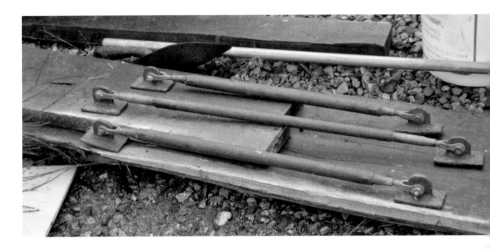

Adjustable metal spreaders. I made these from marine turnbuckles. Each turnbuckle was cut in half, a metal pipe was inserted between the two ends and a swivelable plate was attached to each end. ALAN HOOVER PHOTOGRAPH.

(*facing*) Here we are adjusting the metal spreaders. They are not used to ⊡spread⊡ the canoe, but to shape the hull. Each end can be independently adjusted. Joe Martin (left), Jack Touchie across from him. To Jack's right is Gary Martin, Joe's cousin. Carl Martin, Joe's brother, is to Joe's left. ALAN HOOVER PHOTOGRAPH.

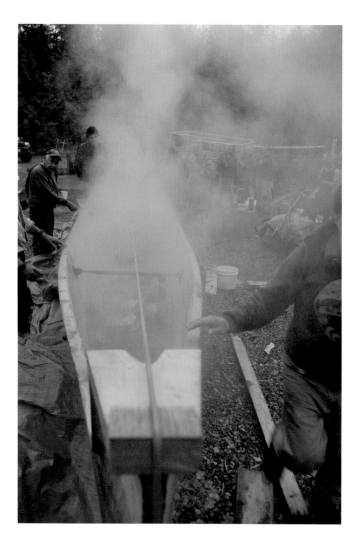

The centre line is used to check the shape of the spread canoe. ALAN HOOVER PHOTOGRAPH.

I'm sighting down the centre line to check the shape of the spread canoe. ALAN HOOVER PHOTOGRAPH.

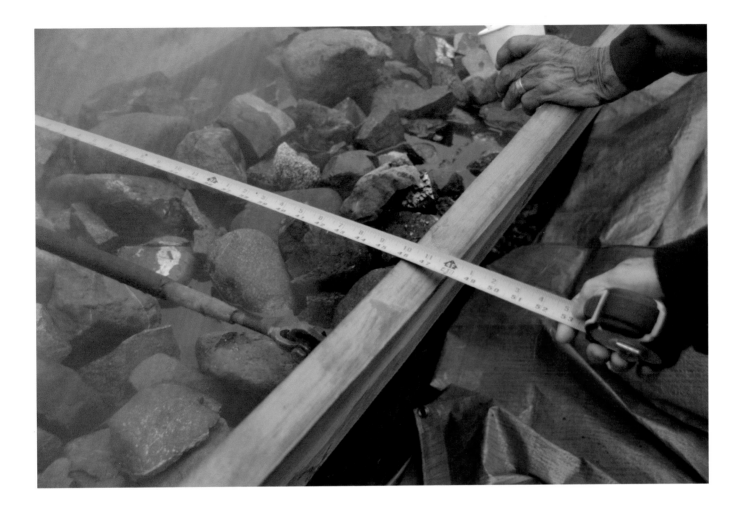

The canoe was spread from 38 inches to a final width of 48 inches. ALAN HOOVER PHOTOGRAPH.

So it's important to go a bit further than you really want, because what you have to do is take all the rocks and water out and then you let it cool off, and then what you got to do is you got to sit on a couple of blocks for a few days, and what will happen is that it will relax and come back. That way it will release the stress in it. Because if you leave it at its widest that you made it and you put in a seat and you go on the ocean in it, it's holding and it's straining on itself, and it can crack. So it's important that it comes back and relaxes a little bit. Sometimes it loses as many as four inches, which is about that much or so (Joe held his hands about four inches apart), and it comes back in that much, which is OK. That's alright. Just let it be that way. That kind of thing is important, because then it will not have that stress under it anymore. So that's something that our people along the coast did for a long, long time, and I have no idea how long ago they started doing that.

Steaming the Hɛhɛwšin canoe at Powell River in 2017. The rocks are being put in as the steaming of the canoe, which will shape the vessel and give it its unique character, begins. Every canoe is an individual with its own history and personality. The wooden bracket is to stop the bow from spreading too much. Edward Sanderson is putting in rocks. PHIL RUSSELL PHOTOGRAPH.

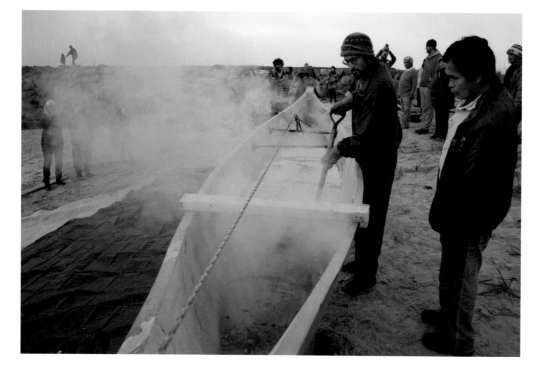

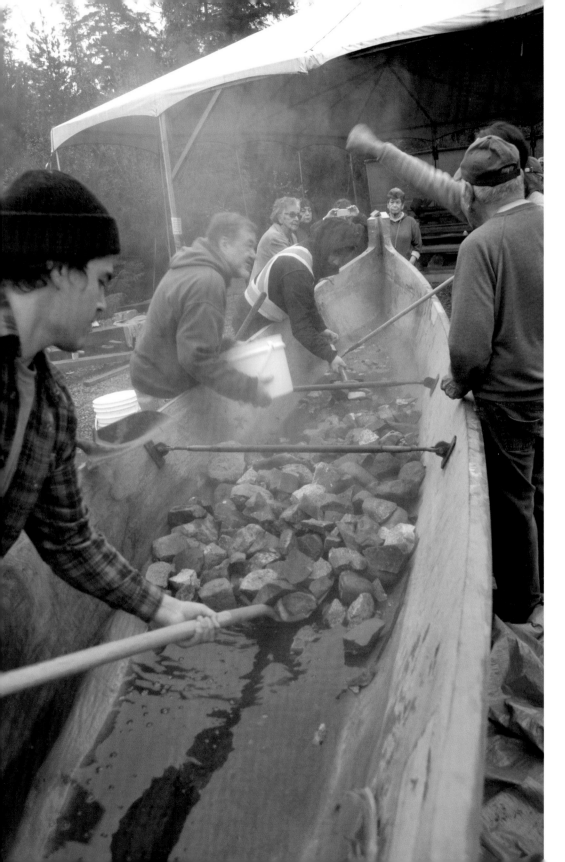

Here we are removing the rocks from the canoe. Note the two metal spreaders in place. November 2018.

ALAN HOOVER PHOTOGRAPH.

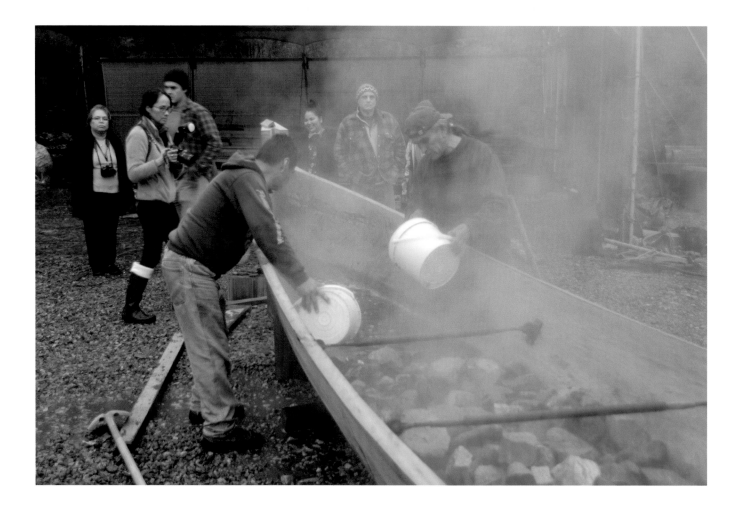

My brother Carl Martin (right) and me are bailing water from the canoe. ALAN HOOVER PHOTOGRAPH.

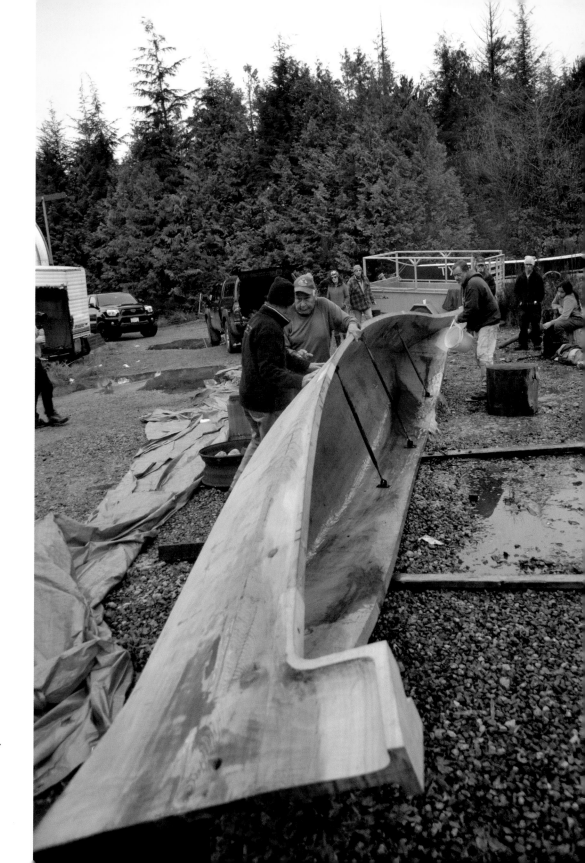

The canoe is now ready to
store under cover and dry out.

ALAN HOOVER PHOTOGRAPH.

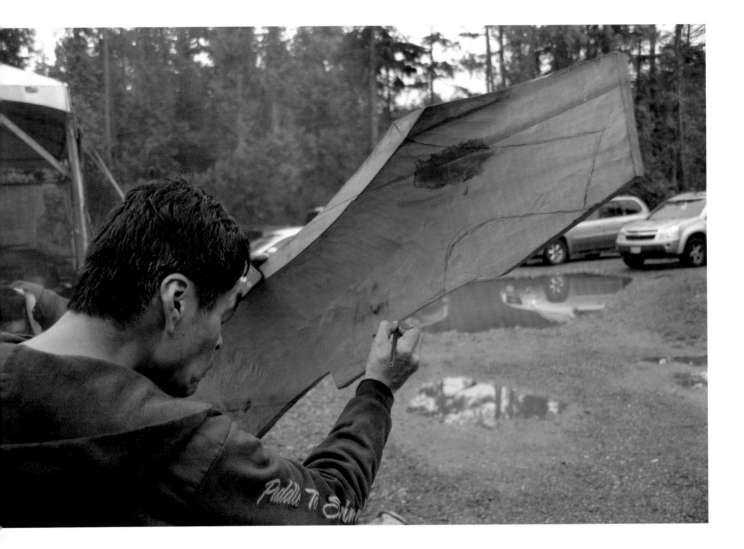

I am sketching in the final shape of the prow.

ALAN HOOVER PHOTOGRAPH.

(facing) The canoe will next
get some seats and then be painted.

ALAN HOOVER PHOTOGRAPH.

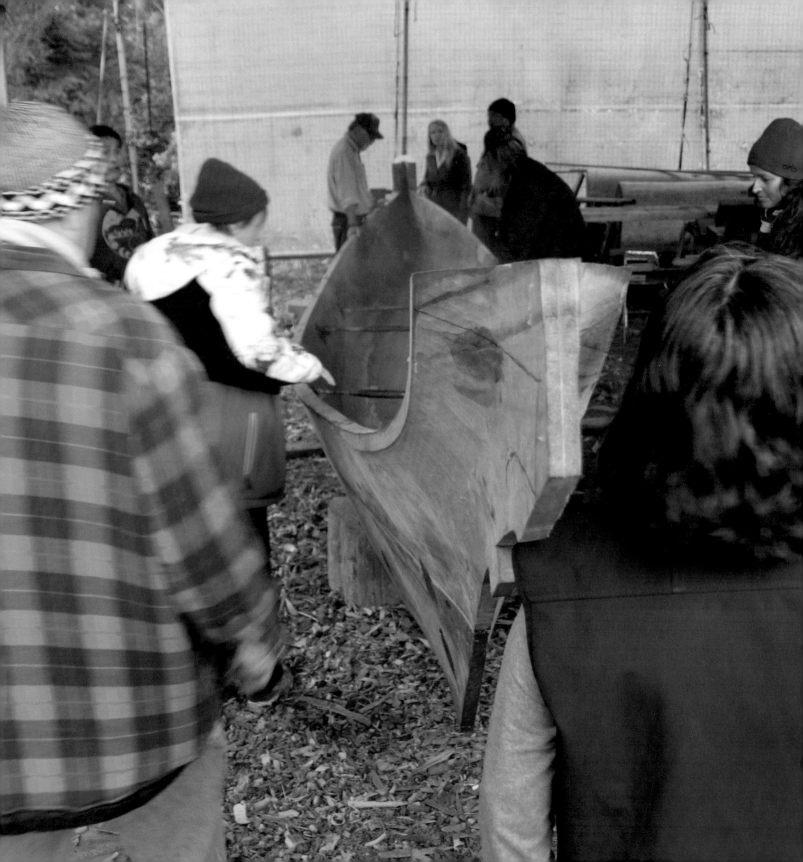

Concluding Statements

CANOE MAKING is an important part of continuing our culture. The canoes are a vector for traditional Nuu-chah-nulth values, laws and reciprocity to the land, water, air and fire which give us life. The canoes have participated in demonstrations to bring awareness to the various effects of colonialism. The canoes have been used to promote Indigenous solidarity and strength at cultural events like Tribal Journeys. They have also hosted thousands of visitors who have come to learn about and experience Tla-o-qui-aht Tribal Parks.

My goal in recent years is to teach people how to carve a canoe in the forest. Not only the technical skills of it, but to follow protocols according to our cultural laws. We need to be sensitive to the environment so that we can live in balance with the forest and its lifeforce, and to protect it for future generations.

Acknowledgements

MANY PEOPLE have helped in the making this book. We would like to thank the following individuals for their contributions: Leigh Hilbert, Leni Hoover, Gisele Martin, Tsimka Martin, Vi Mundy, Eric Plummer, Holly Stocking, Denise Titian, Darrel Ross, Christopher Roy, Philip Russell and Alex Sutcliffe.

Glossary

ALASKAN SAWMILL: A portable sawmill that uses a chainsaw to mill logs (see pages 53–55).

BEAM: Width of the hull. Also used to refer to the maximum hull width.

CHECKING: This refers to the tendency for wood to crack and split when it is exposed to direct sunlight for long periods of time. Covering canoes with cedar bark mats or equivalents (such as tarps) helps prevent this.

CROSS-GRAIN (OR EDGE-GRAIN): Made from the middle of the log, so the grain does not run parallel to the curve of the bottom but is diagonal across the thickness of the canoe's bottom and sides (see page 8).

D-ADZE: A hand adze, the handle of which is shaped like a large capital letter D.

DEPTH HOLE PLUGS: Cylindrical wooden dowels placed in drilled holes along and across the bottom and sides of the canoe hull. When the canoe maker thinning the canoe from the inside reaches the plugs, he has reached the proper hull thickness (see pages 62–63).

DRAW KNIFE: A hand tool with a long blade with two handles that is drawn toward the user to remove shavings (see page 52).

FLAT-GRAIN: When the bottom of the canoe is made from the outside of the log so the grain runs parallel to the curvature of the hull bottom (see page 9).

LONG-BUTTED: A log is long-butted when a bottom end that splays out and has a number of creases with bark seams, or shows inner rot, is cut back to where the log is uniformly circular in diameter (see page 51).

PLUMB LINE: A plumb line is created by suspending a weight on the end of a string. The line is used as a vertical reference line to ensure a structure is centred (see pages 9 and 34, right).

SHEER LINE: The top edge of the side of the canoe from bow to stern.

References

Arima, Eugene Y. *The West Coast (Nootka) People*. Special Publication No. 6. Victoria: British Columbia Provincial Museum, 1983.

Brindle, David. "Community Celebrates Reconciliation Canoe Completion." *Powell River Peak*, November 22, 2017. https://www.prpeak.com/community/community-celebrates-reconciliation-canoe-completion-1.23101137

Coté, Charlotte. *Spirits of Our Whaling Ancestors*. Seattle & London: University of Washington Press, 2010.

Dominion of Canada Annual Reports of the Department of Indian Affairs for the Year Ended June 30, 1901 (p. 318), June 30, 1902 (p. 316), and March 31, 1910 (p. 365).

Kelm, Mary-Ellen. *Colonizing Bodies: Aboriginal Health and Healing in British Columbia, 1900–1950*. Vancouver: UBC Press, 1998.

O'Reilly, Peter. Letter to the Superintendent General of Indian Affairs, October 9, 1882. In *Annual Report Department of Indian Affairs for year ended 31 December 1882*. Ottawa: Government of Canada, 1883. https://central.bac-lac.gc.ca/.item/?id=1882-IAAR-RAAI&op=pdf&app=indianaffairs

Raygorodetsky, Gleb. *The Archipelago of Hope: Wisdom and Resilience From the Edge of Climate Change*. New York and London: Pegasus Books, 2017.

Sjuberg, Gail. "Many Hands Carry Xwaaqw'um Canoe," *Gulf Islands Driftwood*, January 3, 2019. https://www.gulfislandsdriftwood.com/island-life/many-hands-carry-xwaaqwum-canoe

Tate, Brian. "Tsuux-iit (Luna) Update." *Ha-Shilth-Sa Newspaper*, June 3, 2004.

Tofino Time. "Tofino Carver Joe Martin." March 2016. https://www.tofinotime.com/artists/R-JMfrm.htm

Wiwchar, David. "Community Mourns Tsu'xiit," *Ha-Shilth-Sa Newspaper*, January 15, 2013.